IMAGES
of America

CHEROKEE

ON THE COVER: CHEROKEE TRADITIONS RUN DEEP. Here is a game of stickball being played at the Cherokee Indian Fair in 1948 or 1949. The game is still played today and the fair is still an annual event. While traditions do change over time, in Cherokee, many are still celebrated by a people with deep roots in the region. (Photograph by Bill Baker, courtesy of the State Archives of North Carolina.)

IMAGES
of America

CHEROKEE

M. Anna Fariello

ARCADIA
PUBLISHING

31044 0381

Published by Arcadia Publishing
Charleston, South Carolina

Printed in the United States of America

Library of Congress Control Number: 2017953724

For all general information, please contact Arcadia Publishing:
Telephone 843-853-2070
Fax 843-853-0044
E-mail sales@arcadiapublishing.com
For customer service and orders:
Toll-Free 1-888-313-2665

Visit us on the Internet at www.arcadiapublishing.com

CONTENTS

ACKNOWLEDGMENTS

Before there was digital, there were film photographs, light captured in silver emulsion and printed on paper. Each photograph captures a fleeting moment, a moment in history preserved. Our photographs are saved in family albums, stored in envelopes, tossed into drawers, and framed on the walls of our homes. Some are preserved more formally: in archives, museums, and personal collections. In organizing this book, it was my purpose to collect photographs near and far from Cherokee and bring them "home." I was particularly interested in images that had not been published previously and that might reveal new information to members of the Eastern Band and their neighbors.

This book would not be possible without those who preserved the photographs printed within. These include formal collections held by Cherokee's key cultural partners—Cherokee Historical Association, Museum of the Cherokee Indian, and Qualla Arts and Crafts Mutual Inc.—as well as collections by regional and national institutions, including the Great Smoky Mountains National Park Archives, Hunter Library Special Collections at Western Carolina University, Library of Congress, Research Laboratories of Archaeology, Smithsonian Institution, Southern Highland Craft Guild, State Archives of North Carolina, University of North Carolina at Chapel Hill, and the US Geographical Survey. Individuals and private entities who contributed photographs include Scott Ashcraft, Cherokee Publications, Tom Frazier, Lamar Marshall, and Thompson Photo Products. Particular mention must be made of Andy Lett, who generously lent a large part of his vast collection to this volume.

A special thank-you is extended to those who helped identify photographs and shed light on some of the people and places pictured. I was fortunate to share long and valuable conversations with Beloved Man Jerry Wolfe. Also assisting in this effort were Denise Ballard, Roseanna Belt, Mike Crowe, Vicki Cruz, Eddie Swimmer, Terri Taylor, and Lambert Wilson. I am grateful that they saw the value in collecting and saving these images and were willing to share their knowledge with me and with you, the reader.

INTRODUCTION

HOMELAND

The heart of the Cherokee homeland is in the Appalachian Mountains, an upland swath of rarely broken forested ridges and valleys stretching more than 1,500 miles across the eastern United States. This rugged landscape—America's mountain South—is the ancestral homeland of the Cherokee. Although there is little consensus as to when the Cherokee first inhabited this section of the American continent, most scholars agree that they have lived in this place for over 10,000 years.

Ancestral people settled in valleys formed by rapidly flowing rivers and creeks that cut through these mountains. Their communities varied in size from a dozen homes to much larger towns of several hundred people. Historically, each town was made up of a ceremonial center, a cluster of houses, gardens, and outlying fields. Cherokee men and women cleared land for farming and fruit trees. Cultivating fields along rich river bottoms, families grew food, hunted wild game, and set weirs to trap fish from rivers. They gathered native plants for food, medicine, and for making everything else that they needed. In rich bottomlands, they grew sunflowers along with the "three sisters"—corn, beans, and squash. Living in log homes arranged in towns that crossed into portions of eight modern states, the Cherokee call themselves Ani-Giduwagi, the people of Kituwah.

All Cherokee people acknowledge Kituwah as their Mother Town. Today a cultural heritage site, the remains of Kituwah lie along the banks of the Tuckasegee River in western North Carolina just east of present-day Bryson City. Multiple villages filled the site from the 13th through 18th centuries. Clustered around Kituwah were the Valley Towns, Out Towns, and Middle Towns. On the western side of the Great Smoky Mountains (in present-day Tennessee) were the Overhill Towns and to the south, the Lower Towns. The town of Cherokee is in an area traditionally known as Yellowhill. Today, Yellowhill is represented on Tribal Council as one of six townships. The town of Cherokee took its formal name when a US post office was established there in 1883.

If you ask the Cherokee people where they came from, they might relate their creation story, explaining the universe and their place within it. The water beetle figures prominently in this story. Arriving on Earth, there was nothing but water. The little water beetle dove beneath the surface to bring up mud from the bottom of the sea. Slowly, the mud spread out to form the Earth, creating a home for the animals and the original people. Stories can be explanatory like this one, or humorous—like how the little bat got its wings. Stories like these bind a people together to produce an enduring culture with a common language, long history, spiritual practices, and shared land.

HOME LIFE

Cherokee culture put family first, with day-to-day life dominated by a complex clan system that governed domestic alliances and retribution. Seven clans—Bird People, Blue People, Deer People, Long Hair People, Paint People, Wild Potato People, and Wolf People—were at the center of familial relationships. The extended family unit plays a key role in Cherokee life, with families linked across generations. Several traditions support family well-being. If a person is sick or elderly, he or she may be helped by *gadugi*, a community group that provides assistance to those in need.

Elders are revered as the keepers of knowledge; children learn about their community and culture by watching older people.

Traditionally, the family structure was matrilineal, with women controlling a family's property. Women held primary responsibility for the homestead, including the cultivation and harvesting of food crops. As an extension of their roles as preparers of food, women were also the primary makers of their culinary tools, including baskets and pottery. Cherokee women were owners of their household's domestic property; personal property passed from mother to daughter. This confused early travelers—all men—who could not imagine a culture in which women participated in government and enjoyed independence in their personal lives.

Like all people, at some point in their history, Cherokee people made everything. Everything needed to live, work, and play was made by their hands. Given their oral tradition, their earliest history is recorded in their artifacts. Fragments of pottery and baskets reveal what people did in daily life and how they lived. Before the advent of metal and plastic, people in all cultures depended upon natural materials to make things. Clay, wood, stone, shell, copper, mica, plant fibers, and animal hides were processed to create domestic goods and tools. While handcrafted traditions have a place in all cultures, many were abandoned once manufactured items became commercially available. This is not the case with the Cherokee, who continue to value traditional knowledge and skills.

EUROPEAN ENCOUNTERS

For America's indigenous peoples, life was never easy; it was, at least, sustainable. But life began to change dramatically with the arrival of Europeans, who brought measles and smallpox to North and South America. Some scholars estimate that up to 95 percent of indigenous people were killed by European diseases within 150 years of Christopher Columbus's first landing.

When Hernando de Soto arrived in 1540, he found the Cherokee living in small villages, each separated by a few miles. By the time the English reached the shores of Virginia in 1607, the Cherokee had emerged as a populous and powerful tribe. The earliest Europeans traveling through the southern mountains were surprised to see the extent of their habitation. In the late 1700s, William Bartram came through the Cherokee town of Cowee and took note of its size and sophistication. James Adair, a trader among southeastern Indian tribes for 40 years, counted 64 Cherokee towns and villages as part of "a numerous and potent nation." One of the earliest written accounts of Cherokee domestic life came from Henry Timberlake, a colonial soldier who served as an emissary to the Overhill Cherokee during the 1760s. In 1762, Timberlake escorted three distinguished Cherokee leaders to London, where they unsuccessfully attempted to halt the encroachment of settlers into their homeland.

By the late 17th century, colonial traders were making regular journeys into Cherokee lands to trade for baskets and pottery made by women and wood and stone tools made by men. But the main trade product of the Cherokee was deerskins, raw material that the English exchanged for "trade goods" that included iron tools, brass kettles, knives, firearms, and glass beads. The skin of a doe could be traded for a knife, a brass kettle, or 60 bullets. Some items that are common today, like woven cloth, brought a high price. Two yards of flannel were worth the skins of two bucks or four does. Trade was important to the Cherokee and settlers alike, serving mutual interests that contributed to their well-being.

By the late 18th century, European contact meant a steady influx of settlers into Cherokee territory, forcing them to deal with broken treaties, land grabs, betrayals, and battles that seriously weakened their population. From their perspective, the period of the "American frontier" brought continued trauma. One well-documented raid in 1776 was made by Gen. Griffith Rutherford, a hero by Revolutionary War standards but a villain to the Cherokee people. Rutherford assembled a militia of 2,500 men armed with rifles and hatchets. Coming into what is today Jackson County, he entered town after town, burning homes to the ground, destroying the harvest, seizing livestock, and killing anyone who resisted. With crops trampled and storehouses burned, the Cherokee were left without food or shelter. By 1838, a seriously weakened and smaller population faced their greatest trial, the Trail of Tears.

REMOVAL

The election of Andrew Jackson ensured passage of the Indian Removal Act of 1830. After years of broken treaties and the cession of land—and in spite of winning a legal battle at the Supreme Court—the Cherokee were made to leave their homeland. In 1838, federal agents began rounding them up for a forced removal to Indian Territory in the West. Smithsonian ethnologist James Mooney recorded the recollections of some who lived through those tumultuous times: "Squads of troops were sent to search out, with rifle and bayonet, every small cabin hidden away in the coves or by the sides of mountain streams, to seize and bring in as prisoners all the occupants, however or wherever they might be found. Families at dinner were startled by the sudden gleam of bayonets in the doorway."

Cherokee families were forced to leave possessions and property behind. Ancestral farms were distributed to white settlers by lottery; many were simply torched. The forced removal of the Cherokee was known to them as *nvnohi dunatsoyilvi,* "the trail where they cried." Men, women, children, and the elderly were herded into stockaded camps where they were assembled; many did not survive this initial ordeal. By most estimates, 16,000 Cherokees walked the Trail of Tears, a distance of 1,000 miles. A quote from the Eastern Band's website tells their story:

> And so the great migration began, the tragic exodus of a once proud nation . . . There were men and women, old and gnarled. There were newborn babies and unborn babies who chose just this moment to come into the world. There were the blind and the dying consumptives who had to be carried on litters. As they picked up their few belongings they looked about, gazed toward the high peaks of the Great Smokies, toward the mountains that had sheltered them. Then they moved on.

RESISTANCE

With a rich spoken language but no written language, the Cherokee were at a distinct disadvantage in treaty negotiations. A man named Sequoyah decided to remedy that situation by inventing a written alphabet. The writing system invented by Sequoyah is called a syllabary because its sounds are represented syllable by syllable, rather than by individual letters, like the English alphabet. Sequoyah, whose English name was George Gist (or Guess), began to develop the syllabary around 1810 and worked on it for more than a decade. After its official adoption by the Cherokee Nation in 1825, the use of the syllabary grew quickly and Cherokee people learned to read and write their language. Within a short period of time, the literacy rate among Cherokee people surpassed that of their Euro-American neighbors. The *Cherokee Phoenix* was the first newspaper published in the US by any Native American tribe and the first printed in a native language. The *Phoenix* was first issued in 1828 in what was then the Cherokee capital city at New Echota, near Dalton, Georgia. For the most part, parallel columns in the newspaper were printed in Cherokee and English. In Greek mythology, a phoenix arises from the ashes to be reborn. As readers can learn from this book, the Cherokee people have overcome challenges and loss to rise from the ashes of adversity.

After the Civil War, Reconstruction brought change to the American South. By 1890, a newly constructed rail line brought visitors and speculators to the mountains. While many were interested in profiting from the region's natural resources, others came as educators, missionaries, and culture workers. Schools were established in the western North Carolina mountains, including in Cherokee. While early education programs helped forge a place for Cherokee people within an increasingly Anglo society, historic documents support the fact that many children attended school against the wishes of their parents. Once in school, children were forbidden to speak their language or wear native dress. Physical force was sometimes used to keep them from running away. One early oral history noted that a runaway child was chained to his bed.

After Removal, approximately 1,000 Cherokees remained in the dense forests of western North Carolina. The descendants of these few are today's Eastern Band of Cherokee Indians. The Qualla Boundary is the territory where they reside. Although many call the boundary a

"reservation," it is not. A reservation is land given by the federal government to a tribe, but the Cherokee purchased their own land in the 1840s. The boundary's 57,000 acres is a fragment of the extensive original homeland of a vast Cherokee nation. In 1868, the general council of the remaining eastern Cherokee adopted a new constitution and formed a tribal government. In 1889, they were formally incorporated by the State of North Carolina as the Eastern Band of Cherokee Indians.

Today, the Eastern Band is one of three Cherokee tribes among the 565 federally recognized Native American tribes in the United States. These include the Cherokee Nation, United Keetoowah Band, and the Eastern Band of Cherokee Indians. Each of the three Cherokee tribes is a sovereign nation, an independent country within a country. The tribe is governed by a principal chief and tribal council. All three tribes are culturally related; they share a common language and common traditions. All Cherokee tribes look to Kituwah as the heart of their homeland.

COMMUNITY

Most of the western North Carolina mountains remained rather isolated until the railroad came into the region. In 1894, the Murphy Branch of the Southern Railway was built, connecting Asheville to the far western part of the state. The Southern Railway's Murphy Line skirted the Qualla Boundary, stopping at Whittier and Bryson City. Early in the 20th century, before familiar destination sites were established, the Qualla Boundary still had few visitors. The train brought outsiders into the region, some with their eyes on business opportunities and others with an eye on the scenery. Those interested in culture stopped in Cherokee.

In the fall of 1912, the residents of Big Cove held a festival to celebrate traditions that some thought to be fading from practice. Two years later, the entire Cherokee community participated in what would become an annual fall festival, known as the Cherokee Indian Fair. Held each October beginning in 1914, the fair sponsored competitions for agricultural products, domestic goods, arts and crafts, blowgun, archery, and stickball. Historically, competitions such as stickball were rites of passage and means to settle disputes, while today they are a way to bring communities together for recreation and friendly competition. Stickball games, dances, and more private traditions are practiced as a means to instill pride and to strengthen community ties.

The relationship of the Cherokee people to outsiders changed dramatically as the 20th century progressed. The building of the Blue Ridge Parkway and the Great Smoky Mountains National Park in the 1930s began a thriving tourism industry on the Qualla Boundary. The 1940s and 1950s saw the establishment of several of today's key cultural sites. Qualla Arts and Crafts Mutual, one of the country's oldest Native American artisan cooperatives, was founded in 1946. The Eastern Band of Cherokee established other organizations to take control of the interpretation of their heritage. In 1948, the Museum of the Cherokee Indian first opened its doors. *Unto these Hills*, a popular outdoor drama, premiered in 1950. More than six million people have viewed the performance since then. In 1951, the Cherokee Historical Association sent a delegation of tribal leaders to retrace the Trail of Tears. In 1952 the Oconaluftee Indian Village opened, re-creating 18th-century life. Visiting families watch demonstrations of handcrafted traditions in a living history setting. At each of these destinations, Cherokee people share their culture with outside visitors who wish to learn more about them.

Today, Cherokee, North Carolina, is most often thought of as a popular hub of tourism. Thousands come to see these and other popular tourist destinations. Many come through on their way to the Great Smoky Mountains National Park and others stop off from the Blue Ridge Parkway. Cherokee has plenty to see: a museum, an art guild, an outdoor drama, a living history village, a convention center within a casino complex, as well as many, many shops and galleries. Cherokee is a bustling place, a place of destinations, tourism, cultural sites, shops, even broadband. The town takes its name from the people who have inhabited this land for as long as anyone can remember: the Cherokee people.

One

HOME PLACE

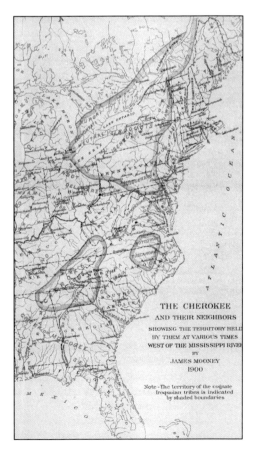

MAP OF CHEROKEE HOMELAND. It is difficult to separate Cherokee the place from Cherokee the people. The land and people are intricately linked through history and tradition. This map, drawn by ethnologist James Mooney in 1900, shows the vast land holdings inhabited by Cherokee people prior to the encroachment into their homeland by European settlers. Cherokee homeland once extended to portions of eight modern states, including almost all of the upland South. This map was included in Mooney's *Myths of the Cherokee*, published by the US Bureau of American Ethnology. The bureau would later become part of the Smithsonian Institution. (Author's collection.)

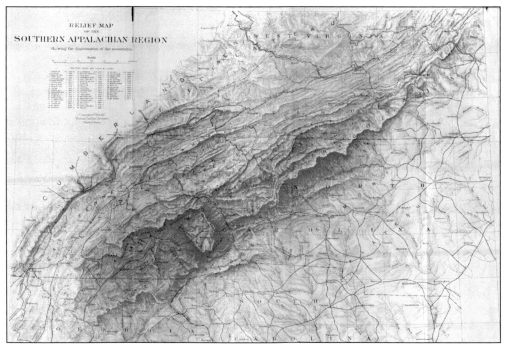

RELIEF MAP. This US Geological Survey map shows the rugged terrain of the southern Appalachians, well illustrating the steep sides of the mountains and the depths of the valleys. The town of Cherokee is located in the darkest section of this map, between the Blue Ridge and Great Smoky Mountains. (Courtesy of US Geological Survey.)

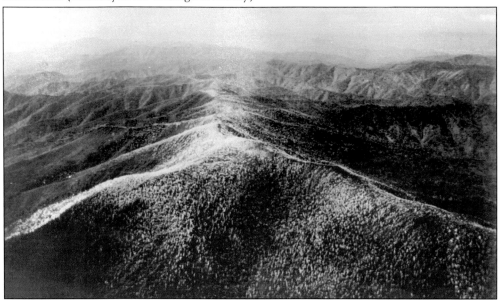

MOUNTAINS AND RIDGELINES. The area surrounding Cherokee is steep. While rivers flow through the valleys, the mountains rise to 5,000 and 6,000 feet. This aerial photograph taken in the early 20th century illustrates the rough terrain. The photograph was made by Robin Thompson, one of two photographer brothers from Knoxville, Tennessee. (Courtesy of Hunter Library Special Collections, Western Carolina University and Thompson Photo Products.)

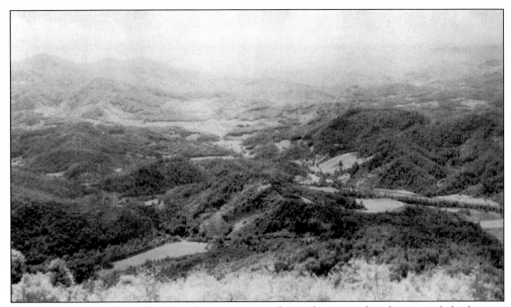

RIVER VALLEY. Traditionally, Cherokee towns were located near creeks where people had access to free-flowing water. Small streams fed into larger ones that in turn fed the region's waterways, including the Oconaluftee River. The land owned by today's Eastern Band of Cherokee Indians comprises a small portion of the original 140,000 square miles of their homeland in the southern Appalachians. What is theirs today lies in the Oconaluftee River valley, bounded by the Great Smoky Mountains. (Courtesy of Andy Lett.)

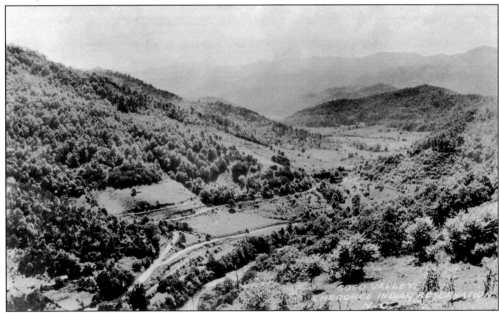

SOCO VALLEY. Another steep valley through the Smokies is Soco Gap, which cuts through the mountains at a point that separates the French Broad and Little Tennessee watersheds, as well as the border between Jackson and Haywood Counties. Seen in the center of the photograph and cutting through the gap is US Highway 19, also known as Soco Road. The community of Soco is just inside the eastern edge of the Qualla Boundary. (Courtesy of Andy Lett.)

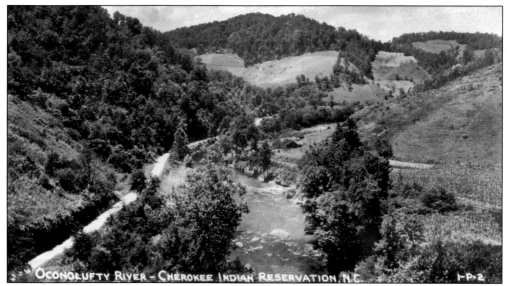

"CHEROKEE INDIAN RESERVATION." This postcard shows the Oconaluftee River valley cutting through the Great Smoky Mountains. Today, the valley is shared between the Great Smoky Mountains National Park and the Qualla Boundary. The boundary is not a reservation, although many call it that. This land, owned by the Eastern Band of Cherokee, was not given or assigned by the federal government; instead, the tract was purchased after the federal government drove the majority of the Cherokee people westward along what has become known as the "Trail of Tears." (Courtesy of Andy Lett.)

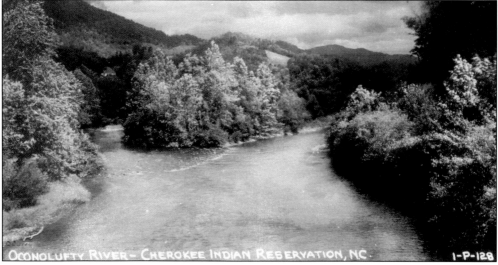

OCONALUFTEE RIVER. Up to the early 20th century, the river that is today known as the Oconaluftee was frequently spelled "Oconalufty" or sometimes simply "Lufty." The name, spelled either way, is a translation from the Cherokee meaning "by the river." The Oconaluftee River is fed by several creeks that have their headwaters in the Great Smoky Mountains. Historically, rivers played an important role in Cherokee life, providing fish for food and navigation by canoe. Water transport was common—and practical—where a mountainous terrain and dense vegetation complicated overland travel. Almost all the water in and around Cherokee flows down from the Smokies and Balsam Mountains. Both ranges have peaks topping over 6,000 feet. (Courtesy of Andy Lett.)

KITUWAH MOUND. Located between today's Bryson City and Cherokee, Kituwah is considered the ancestral home of the Cherokee people. A sacred and prominent religious center, it is known to all Cherokee as the "Mother Town." Beginning around AD 300, a settled people built up the land to form an elevated mound where a fire burned at the center of an ancient council house. (Author's collection.)

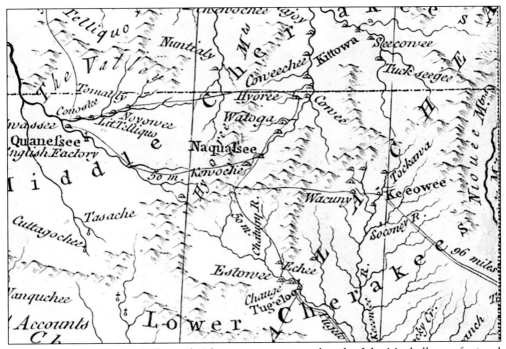

"CHERAKEE SETTLEMENTS." This mid-18th-century map is attributed to John Mitchell, a professional geographer and cartographer. While the map is more than 250 years old, there are places on it that are recognizable today. Toward the top of the map, Mitchell has identified "Kittowa," the Mother Town of Kituwah. To the south is "Keeowee," once a prosperous economic center that is today's Cowee. (Courtesy of Lamar Marshall.)

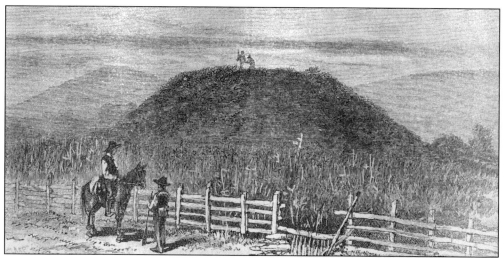

"NEAR FRANKLIN, N.C." This drawing of a mound near Franklin appeared in *Harper's* magazine in 1880. The mound is probably Nikwasi. Today, the Nikwasi mound still stands, but it is hemmed in by buildings and roadways. *Harper's* was first published in 1850, before the advent of photography. Its travel articles were illustrated with drawings and engravings like this one. (Author's collection.)

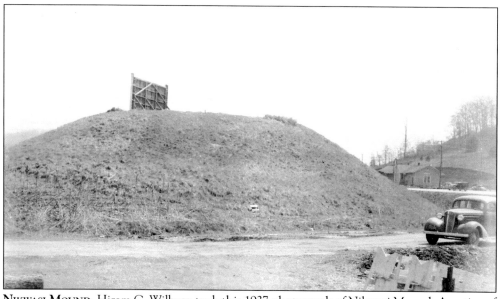

NIKWASI MOUND. Hiram C. Wilburn took this 1937 photograph of Nikwasi Mound. A native of South Carolina and graduate of Clemson College, Wilburn worked as a land surveyor for the North Carolina Park Commission before being employed by the Civilian Conservation Corps (CCC) as a trail foreman. When the CCC dissolved in 1942, Wilburn's official work with the Great Smoky Mountains National Park ended. Making his home in Waynesville, North Carolina, Wilburn became the unofficial historian for the North Carolina side of the park. In this photograph, a 1930s automobile can be seen rounding the curve of what is today Main Street in Franklin. (Photograph by Hiram Wilburn, courtesy of the Great Smoky Mountains National Park Archives.)

CULLOWHEE MOUND. Another mound photographed by Hiram Wilburn is in the nearby community of Cullowhee, a word that translates as "Place of Judaculla." Judaculla is a legendary giant and master of animals who protected the Cherokee's sacred hunting grounds. The mound at Cullowhee was well known and was excavated in the late 1800s by agents of the Valentine brothers, who dug into many mounds in western North Carolina. In this 1937 photograph, the mound is barely visible as a rise in the middle ground of the landscape. By this time, the mound had already been eroded by weather and farming. (Courtesy of Research Laboratories of Archaeology, University of North Carolina at Chapel Hill.)

LOSS OF MOUNDS. There were thousands of mounds in the United States that no longer exist today due to road and building projects. A mound in Cullowhee was bulldozed in the 1950s to make way for new construction on the campus of Western Carolina University. From excavations at these sites, archaeologists determined that Cherokee ancestors built villages, cultivated crops, gathered wild plants, and carried out the activities of daily life. (Courtesy of Research Laboratories of Archaeology, University of North Carolina at Chapel Hill.)

NUNUNYI MOUND. Like many indigenous Americans, the Cherokee built earthen mounds on which to elevate their council houses. These council houses and other important residences were elevated to increase their visibility and stature. After years of erosion and farming, many mounds do not look like mounds at all. Photographed in 1937, Nununyi Mound is located within the town limits of Cherokee along the banks of the Oconaluftee River. (Photograph by Hiram Wilburn, courtesy of the Great Smoky Mountains National Park Archives.)

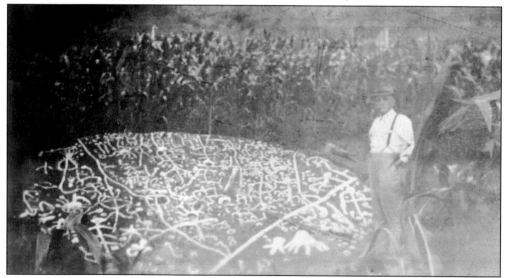

JUDACULLA ROCK. Petroglyphs—a type of rock art—are images inscribed into rocks. Native people made these markings by pecking, abrading, or scratching a rock. Some glyphs were created or used during rituals or ceremonies; others may tell a story. The markings on Judaculla Rock were made at different times. Archaeologists estimate that most of the glyphs are between 300 and 1,500 years old. This photograph shows the scale of Judaculla Rock, acknowledged to be the largest petroglyph in North Carolina. The site is located 40 miles away in Jackson County along the Caney Fork, a tributary of the Tuckasegee River. Its location was important to Cherokee settlements and their hunting grounds. The rock may have served as a boundary marker or map. In this photograph, the markings on the rock have been filled in with white chalk. (Courtesy of Scott Ashcraft.)

JUDACULLA. According to Cherokee legend, Judaculla was a slant-eyed giant who lived high up in the Balsam Mountains. He guarded his hunting grounds from his Judgment Seat, today known as the Devil's Courthouse, a site reached from the Blue Ridge Parkway. Once, a party of disrespectful hunters came through his land and Judaculla chased them down the mountain. With a mighty leap, the angry giant landed on a large boulder. Putting his hand down to steady himself, he left his mark on the rock's surface. The impression of his hand can still be seen. (Drawing by Nancy-Lou Patterson, courtesy of Cherokee Publications.)

A HERITAGE SITE. The oldest markings on Judaculla Rock are over 3,000 years old. These were made when soapstone was quarried from the surface of the rock, with people chipping off pieces to carve into bowls. The scars left from these activities can still be seen where soapstone bowl material was cut from the main rock. Judaculla Rock was opened to the public after consultations with the tribal preservation office and regional archeologists. The Jackson County Parks and Recreation Department maintains the heritage site. (Author's collection.)

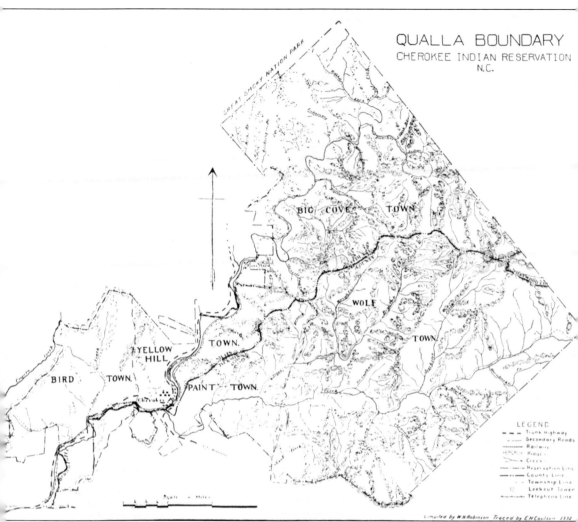

QUALLA BOUNDARY
CHEROKEE INDIAN RESERVATION
N.C.

BIG COVE TOWN

WOLF

TOWN

YELLOW HILL

TOWN.

BIRD TOWN.

PAINT TOWN.

LEGEND
— — — Trunk Highway
— · — Secondary Roads
————— Railway
————— Creek
— · — Reservation Line
————— County Line
— · · — Township Line
Lookout Tower
————— Telephone Line

Compiled by W.N.Robinson Traced by E.H.Coulson 1932

QUALLA BOUNDARY. Today's Qualla Boundary—approximately 57,000 acres, or 82 square miles—is located in Jackson and Swain Counties. The traditional communities of Bird Town, Paint Town, Wolf Town, and Big Cove are noted on this map. The town of Cherokee—the economic hub and seat of tribal government—can be seen as small dots along the river along the southern edge of Yellow Hill. The map, made in 1932, appears in *The Eastern Cherokees: How they live today / their History,* a booklet published in 1937. (Author's collection.)

Two

FAMILY LIFE

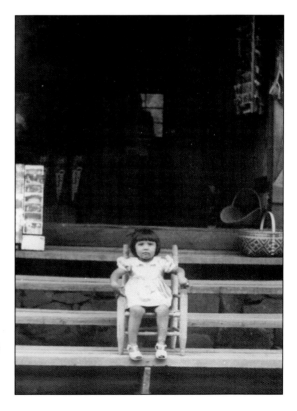

LITTLE GIRL. This young Cherokee child is posed in a chair on the steps of a porch. Sitting on the stair, at right, is a rivercane basket with a white oak handle. Made in a typical Cherokee style, carrying baskets like this one were used in the garden or carried to market. This basket is woven with a diamond pattern. (Courtesy of Andy Lett.)

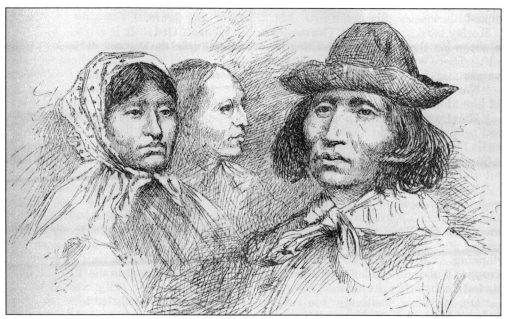

ENGRAVED PORTRAIT. This anonymous engraving of a group of Cherokee people appears in an 1880 issue of *Harper's*. This may well be one of the earliest published images of people identified as Cherokee. The woman on the left wears a traditional bandana headscarf; the man wears a wide-brimmed cloth hat. Today, there are three Cherokee tribes among the 565 federally recognized Native American tribes in the United States—the Cherokee Nation, United Keetoowah Band, and Eastern Band of Cherokee Indians. (Author's collection.)

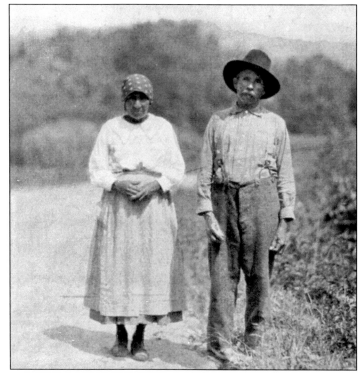

FARM COUPLE. This Cherokee couple, pictured walking along a country lane, is dressed in a fashion similar to the 19th-century engraving above. The woman wears a skirt and apron, with her head covered with a bandana headscarf. The man wears pants held up by suspenders and a wide-brimmed hat similar to one in the engraving. This photograph, appearing in a 1928 publication promoting the Great Smoky Mountains National Park, illustrates the fact that this type of dress was consistent across several decades. (Author's collection.)

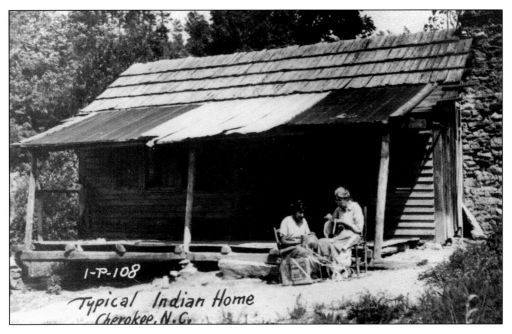

HOME ON THE PORCH. These two postcards include a number of artisans working on their porches. The postcard above, labeled "Typical Indian Home / Cherokee, N.C," includes two women weaving baskets. The baskets in their laps are white oak ribbed baskets. The hoop handle is visible on the older woman's basket. It is believed that the women are Nicey Lossiah and Rachel Taylor. The postcard below, labeled "Home of a Cherokee Pottery Maker," shows Maude Welch with some of her wares. Both homes are typical of the region. Each is built of wood, with a shake roof, a shed porch, and stone chimney. (Above, courtesy of Andy Lett; below, courtesy of University of North Carolina at Chapel Hill.)

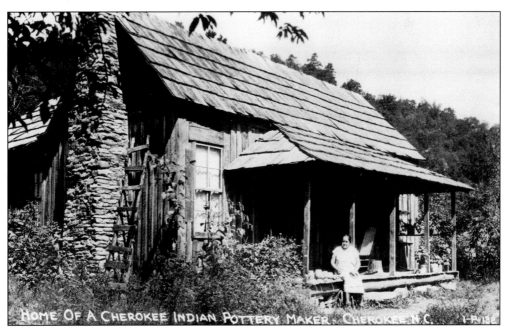

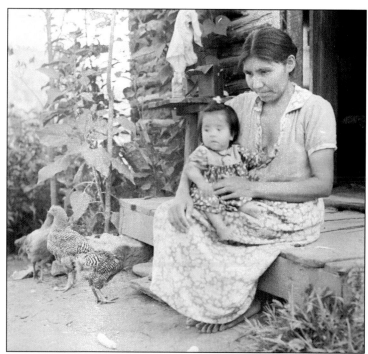

SITTING A WHILE. A mother sits with an infant child on her lap on the porch of the Nedde family home. At her feet are the family's hens, which no doubt provide them with eggs. Whoever took this picture set a Brownie camera case on the table. Such compact cameras were among the first point-and-shoot cameras available to the public. (Courtesy of the Great Smoky Mountains National Park Archives.)

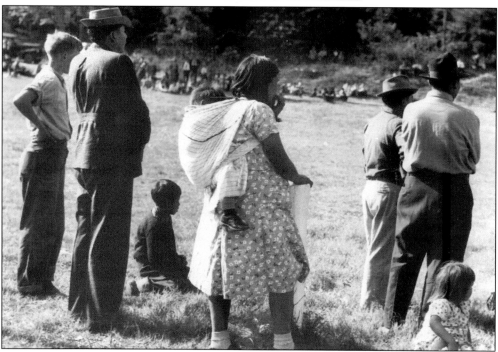

BABIES ON THEIR BACKS. This method of carrying babies and young children on the backs of their mothers persisted into the 1960s. It is seldom seen today. Nearly any photograph from the early 20th century in which women and children are present includes a mother carrying her child in this way. A strip of cloth wound across the mother's shoulders served as a sling for the child. Mothers carried their babies this way until they were two or three years old. (Courtesy of Andy Lett.)

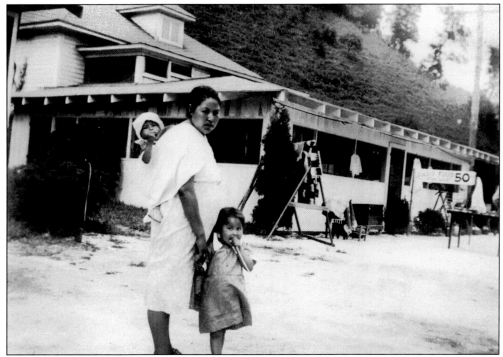

HANDS-FREE. This way of carrying babies and young children allows a mother a free hand to hold a toddler (above) or snack on an ice-cream cone (below). The mother in the lower photograph is Elzina Tramper Bradley. This photograph was most likely taken at the Cherokee Indian Fair, an annual fall harvest festival. (Both, courtesy of Andy Lett.)

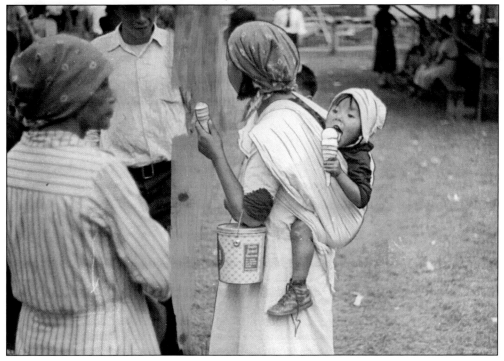

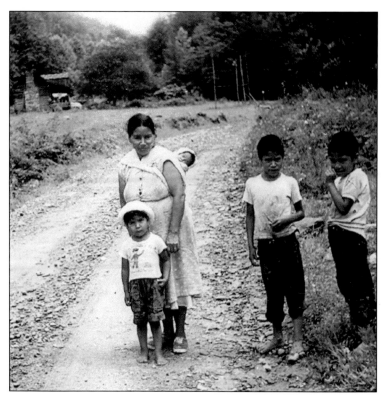

FAMILY ON THE ROAD. Cherokee people put family first. The extended family plays a key role in Cherokee life, with families linked across generations. The traditional Cherokee family structure was matrilineal, with women controlling a family's household property. (Courtesy of Andy Lett.)

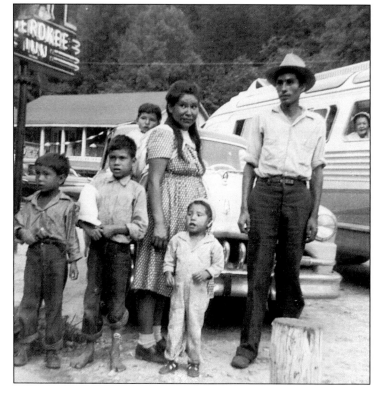

FAMILY IN TOWN. This family of six stops in front of the Cherokee Inn. The mother holds her child in the typical wrapped sling. One of the boys is barefoot, a not-too-rare sight at the time. Children often had a single pair of shoes to wear to school and frequently outgrew them before the year was out. Behind the family, the streets of Cherokee proper are busy. To the right, a tour bus drives through town. After 1934, with the opening of the Great Smoky Mountains National Park, tourism became part of everyday life. (Courtesy of Andy Lett.)

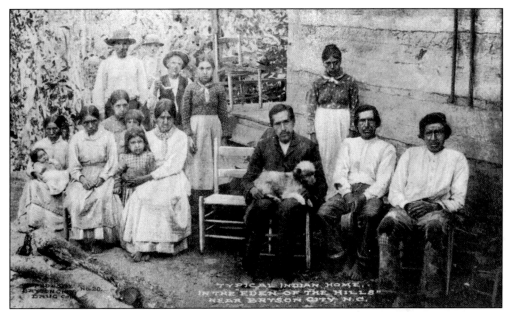

"Typical Indian Home." This postcard shows a family living "in the 'Eden of the Hills,' near Bryson City, N.C." The county seat of Swain County, Bryson City is west of Cherokee. In between is the community of Bird Town, one of six townships that make up the Qualla Boundary. The postcard was produced by the Bryson City Drug Company. (Courtesy of Andy Lett.)

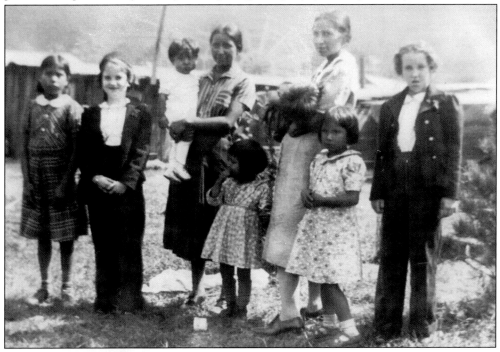

Mothers and Children. These two mothers stop to have their picture taken with children of varying ages. Two of the girls are in uniform. The day must have marked an important event, perhaps the opening day of the 1941 Cherokee Indian Fair. Even in the 21st century, the annual Indian Fair begins with a parade through town. (Courtesy of Andy Lett.)

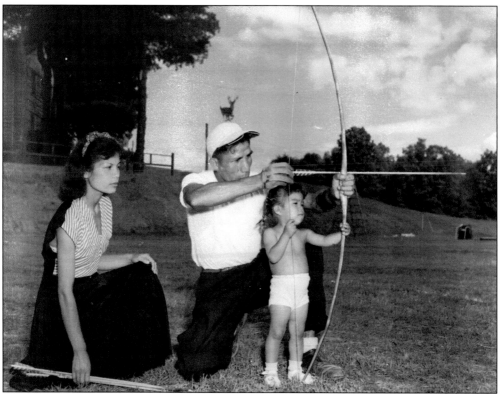

TAKING AIM. This 1949 photograph shows archer Joe Driver showing his two-year-old daughter how to notch an arrow into a bow while his wife looks on. This professionally shot Acme Newspictures photograph was taken at the Southeastern Archery Tournament at Bent Creek Ranch in Asheville, North Carolina. Asheville is about an hour east of Cherokee. (Courtesy of Andy Lett.)

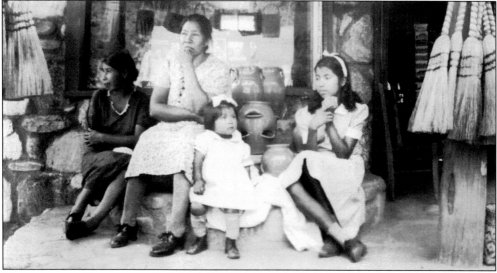

MOTHERS AND DAUGHTERS. Two women sit with two girls among pottery jars on display. A number of brooms are on the right. Neither of these items looks much like a product handmade by Cherokee people. (Courtesy of Andy Lett.)

WEARING CALICO. Everyone in this group of women and girls is wearing calico, a colorful cotton cloth popular in the 20th century. While Cherokee women favored colorful head scarfs, it is less common to see so many dresses made of the colorful fabric. During the Great Depression, the manufacturers of flour began to package flour in colorful fabric bags that women could use afterward for making clothing for their families. (Courtesy of Andy Lett.)

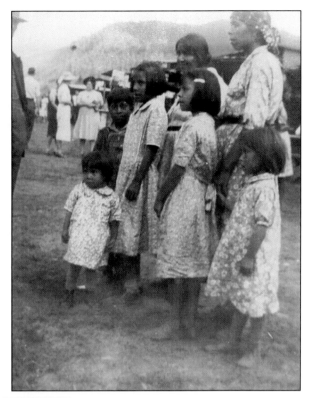

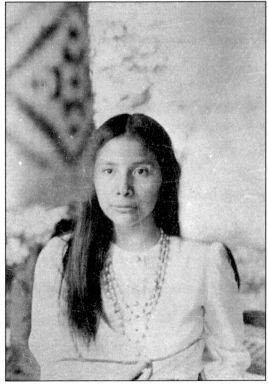

YOUNG WOMAN. This beautiful girl is posed in front of a large rivercane basket. Such baskets were typically used for storage and made to safeguard dry foodstuffs, clothing, or other domestic goods. To maximize their capacity—and minimize the space they occupied—storage baskets were often taller than they were wide. Depending on the size, they held all manner of things. The natural aeration of the single weave allowed stored goods to remain dry. (Courtesy of the Great Smoky Mountains National Park Archives.)

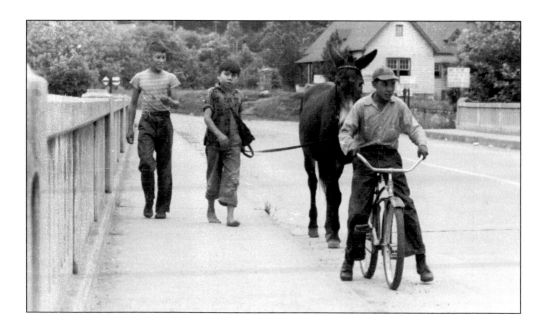

THREE BOYS. Three boys (above) cross the Oconaluftee River Bridge—on foot, on a bike, and leading a mule; a second group of boys (below) paddles a canoe. Rivers played a key role in Cherokee life, offering fish for food and travel by canoe. Throughout history, water transport was common and practical where a mountainous terrain and dense vegetation complicated overland travel. Communities made dugout canoes and still demonstrate their making at the Oconaluftee Indian Village. The boys below are out for fun paddling a modern canoe. (Both, courtesy of Andy Lett.)

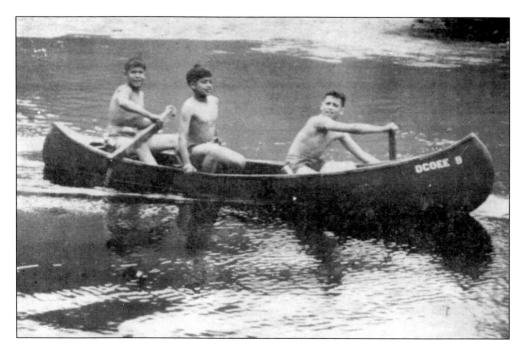

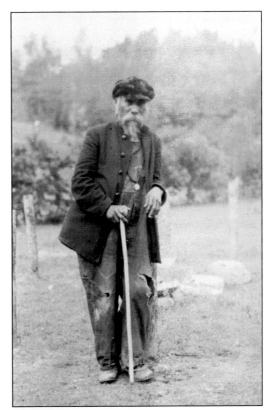

OLD MEN. Both these old men wear overalls and caps, typical clothing for early-20th-century rural communities. The photograph at right of an unidentified man was taken in 1936. The man below is identified as Segli Nedde. (Both, courtesy of the Great Smoky Mountains National Park Archives.)

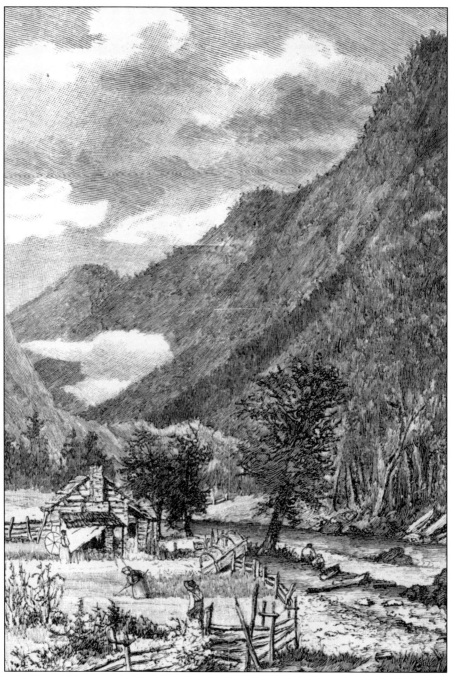

"Valley of the Noonday Sun." The mountains and valleys in and around Cherokee are steep—so steep that in winter the sun comes up over the mountaintops late in the morning. This engraving, from an early graphic depiction of the region, includes a quiet homestead on the valley floor flanked by the steep Appalachian Mountains. A mist settles low in the valley behind a log cabin. The illustration was published in the late-19th-century travel narrative *The Heart of the Alleghanies*, by Wilbur G. Zeigler and Ben S. Grosseup. (Courtesy of Hunter Library Special Collections, Western Carolina University.)

Three

WORK AND SCHOOL

LOG CABIN. This homestead is at the Oconaluftee Indian Village, a re-creation of Cherokee life in the 1750s. Log cabins were traditional homes in the Appalachian Mountains both for Cherokee people and European settlers. People in the 1700s and into the 20th century built their homes from available materials. The chimney is stone. The roof is shake, thin slabs of wood split into shingles. (Courtesy of the Great Smoky Mountains National Park Archives.)

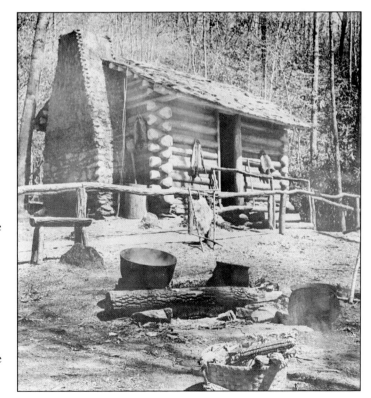

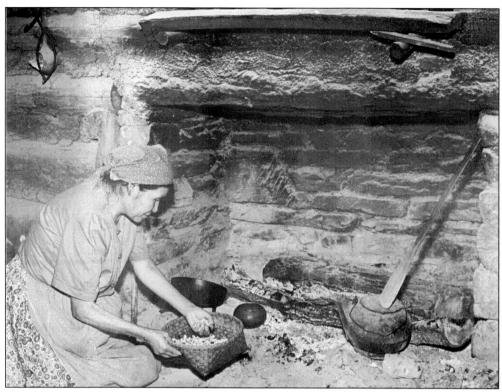

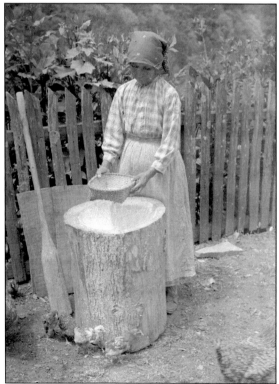

AT THE HEARTH. Although this woman is a historic interpreter at Oconaluftee Indian Village, her work at this cooking hearth is typical of the way people lived and cooked for centuries. In her hand, she holds a basket known as a sifter, a woven open tray used to prepare grains. (Courtesy of the Great Smoky Mountains National Park Archives.)

USING A SIFTER. Various types of shallow baskets—made from either rivercane or white oak—were used to process and serve food. The weave and shape of each type of open-weave tray was varied to fit a particular purpose. Larger flat-bottomed winnowing baskets were used to separate kernel from shaft. A meal sifter was made with a finer weave than the more open-weave hominy basket. This woman is sifting either corn or grain that has been pulverized using the pounder at her feet. (Photograph by John H. Hemmer, courtesy of the State Archives of North Carolina.)

Using a Corn Pounder. This human-sized mortar and pestle is known locally as a corn pounder. Approximately four feet in height, a hardwood pole shaped with its upper end weighted was held vertically over a log stump. Corn or chestnuts were placed in a depression carved into a log stump. The heavy mortar was rotated in the depression, grinding corn or chestnuts into meal. It was said that an experienced pounder could convert a bushel of corn into meal in 30 minutes. Both these women are demonstrating this technique at the Cherokee Indian Fair. The photograph at right shows the daughter of Carl Standing Deer at the 1935 fair. The women below are not identified, but the photograph appeared in a booklet from 1937. (Right, courtesy of the Great Smoky Mountains National Park Archives; below, author's collection.)

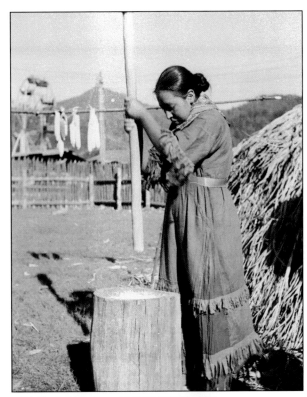

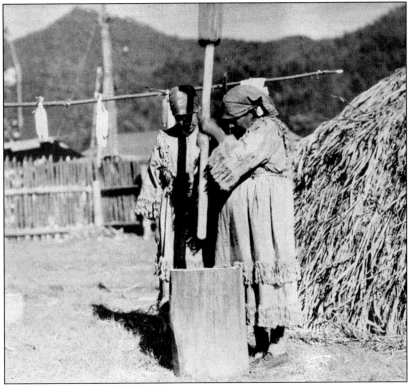

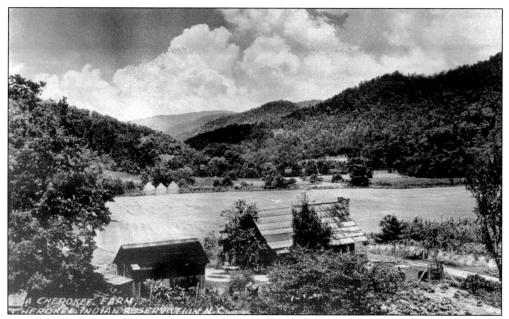

WORKING A FARM. Farming was a common occupation well into the 20th century. This homestead has a vegetable garden at the lower right. No doubt, the family who lived here grew the "three sisters"—corn, beans, and squash. The farmstead overlooks a large field ready for cultivation. In the distance, there are three haystacks. Hay was cut, dried, and stacked by hand to be fed to livestock over the winter months. (Courtesy of Andy Lett.)

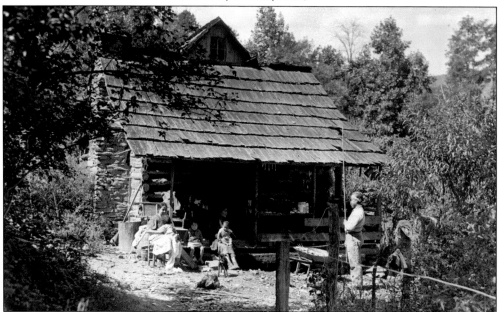

FAMILY AT HOME. There are several versions of this photograph of a family in front of their home, a typical log structure with a shake roof. The man of the house stands in the yard holding a blowgun, a weapon traditionally used to hunt small game, such as squirrel or rabbit. While farming was common, hunting continued to provide food and trade goods, such as animal pelts. (Courtesy of Andy Lett.)

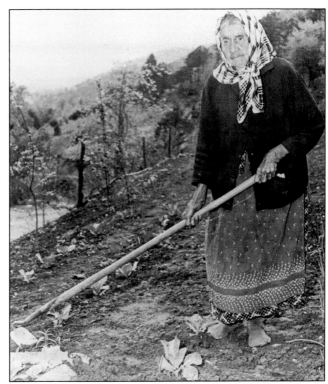

DOING THEIR PART. A photograph from the 1940s (right) is captioned, "Oldest living woman of the tribe, 96-year-old Rachel Reed working in her victory garden. This year she doubled her effort to contribute to the war effort." American citizens of all ages were encouraged to grow their own food during World War II. Children also participated in the war effort, with schools hosting their own victory gardens. Below, children are armed with hoes ready to work. (Both, courtesy of Andy Lett.)

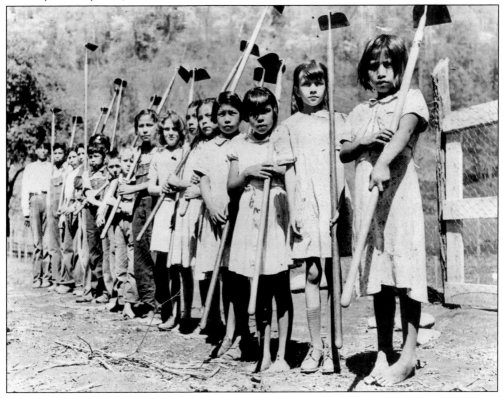

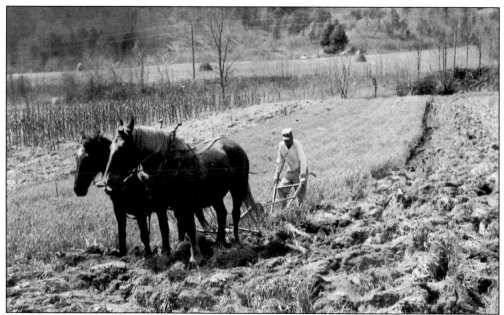

FAMILY FARMS. At the turn of the 20th century, most people in western North Carolina were farmers. This was no different in Cherokee, where growing one's own food took up a large part of the day. Vegetable gardens, or kitchen gardens as they were sometimes called, were planted nearby. Corn, beans, and potatoes—crops grown in quantity and stored over winter—were planted in fields. The photograph above, taken by the Bureau of Land Management, includes a beautiful team of horses plowing under a cover crop of rye and vetch. The picture was taken on the Joe Lambert farm. The George family, seen below, works together, readying timber for construction or sale. Cherokee families often work together for community well-being. If a person is sick or elderly, they may be helped by gadugi, a community group that provides assistance to those in need. (Above, courtesy of Cherokee Historical Association; below, courtesy of the Museum of the Cherokee Indian.)

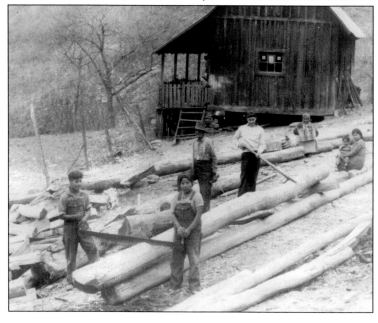

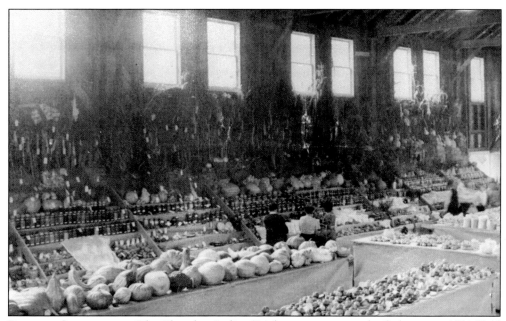

PRODUCE COMPETITIONS. The Cherokee Indian Fair began as an annual tribal event in 1914. Held every autumn, like a harvest festival, the fair awards prizes for agricultural and domestic products as well as arts and crafts. This display was included in the 1941 fair program, showing harvested produce and canned goods. The next year, the *Jackson County Journal* ran a short piece announcing that the Indian Fair would not be held that year, as part of the war effort to conserve rubber and gas. The fair resumed in 1946. (Courtesy of the Museum of the Cherokee Indian.)

FAMILY AT THE FAIR. Fall harvest festivals were common in communities where many families grew and put up their own food. Begun in the 19th century, local harvest festivals with agricultural competitions continue to be held today. This photograph was taken at the 1946 Cherokee Indian Fair, an annual showcase for a community's work and pride. The family is admiring jars of canned vegetables. The lids on these are the screw-on zinc type, not the split lid with canning flat used today. With a nod toward the war effort, a sign above the display reads, "I am now Commander-in-chief of our farm." (Courtesy of the State Archives of North Carolina.)

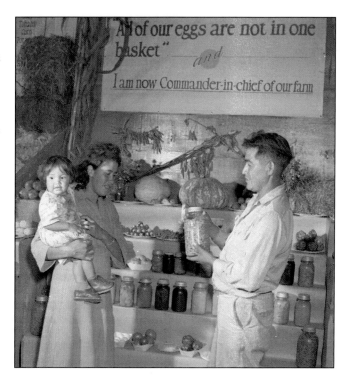

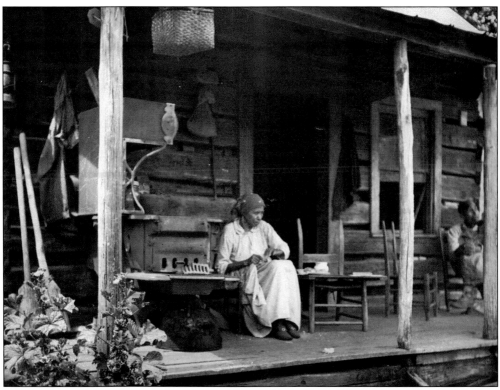

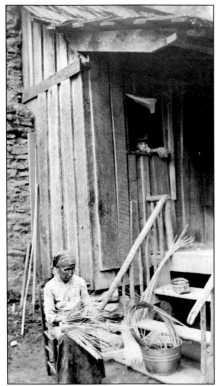

MAKING POTTERY AT HOME. An unidentified woman is making pottery on her porch. She is forming a small piece on her lap; her tools and a finished piece are on the chair next to her. She wears the same calico headscarf as Nancy Bradley (seen at left), typical for women of the time. Hanging above her head is a handled white oak basket. Such baskets were sturdy and usable for carrying wood, vegetables, or most anything else. A woodstove is just to the left; perhaps she burned her pottery in this stove, although most potters fired their pottery in a pit outdoors. (Courtesy of Museum of the Cherokee Indian.)

MAKING BASKETS AT HOME. Like many basket weavers, Nancy George Bradley made her baskets at her home in Wright's Creek. Weavers (and potters) often worked out of doors to accommodate their materials. With bundles of rivercane on the steps nearby, Bradley forms a basket on her lap. A roll of cane sits in a tub of water to keep it pliable. On the steps of her porch is a small double weave tray woven with an arrowhead design. Looking on is her grandson John Maney, who would grow up to become known for making pottery. The photograph is from the 1940s. (Photograph by Hiram Wilburn, courtesy of the Great Smoky Mountains National Park Archives.)

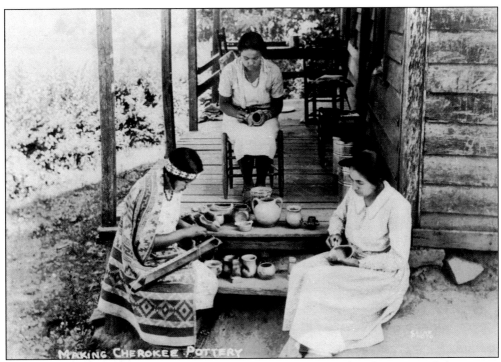

A FAMILY OF ARTISANS. While this postcard is labeled "Making Cherokee Pottery," the woman at left is working on a bead loom. The three women are believed to be (from left to right) Cora Arch (Wahnetah); her mother, Ella Long Arch; and her sister-in-law Sarah Arch. Wahnetah learned the techniques of coiling and modeling pottery from her mother. She used the coil method to form her pots and then paddle-stamped them to add a surface texture. She was active in cultural preservation, working with the Oconaluftee Indian Village to create authentic pottery demonstrations and joining Qualla Arts and Crafts cooperative as a charter member in 1946. (Courtesy of Hunter Library Special Collections, Western Carolina University.)

A FAMILY OF POTTERS. This 1940 photograph shows Tinie Bigmeat Thompson and Elizabeth "Lizzie" Bigmeat Jackson and their children making pottery owls in their yard. While Tinie is working on a clay owl, Lizzie grinds clay with a meat grinder. The two are part of a large family of potters. Their mother, Charlotte Welch Bigmeat, had five daughters, all of whom made pottery: Tinie Bigmeat Thompson, Ethel Bigmeat Queen, Elizabeth Bigmeat Jackson, Mabel Bigmeat Swimmer, and Louise Bigmeat Maney, who married John Maney. (Photograph by Bill Baker, courtesy of the State Archives of North Carolina.)

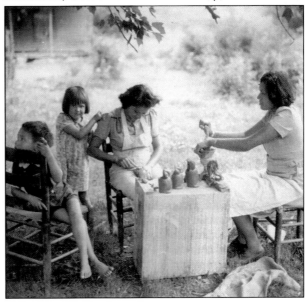

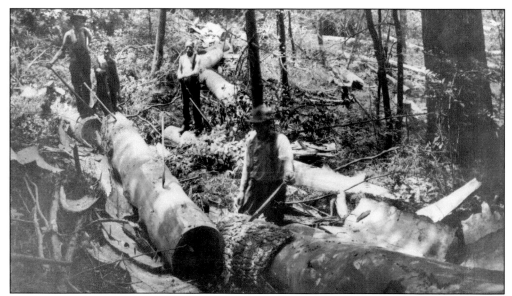

CUTTING TIMBER. Settlers began moving into the Smokies in the late 18th century, most living on small subsistence farms. The coming of the railroad in the late 19th century brought an increased interest in the vast virgin forests of the Smokies. Even when men began cutting timber for cash in the mid-19th century, there was little noticeable effect on the forest. Men and animals could only carry so much. By the turn of the 20th century, technological advances and the need for lumber escalated production. Mountain people who had once farmed the area now cut trees for a living, attracted to logging by the promise of security and a steady paycheck. In this photograph, a crew is peeling bark from felled hemlock trees. (Courtesy of the Great Smoky Mountains National Park Archives.)

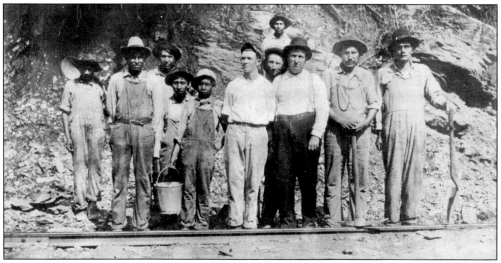

LUMBERING CREW. In the early to mid-20th century, most people worked at home, and outside jobs were rare. This 1910 Whiting Lumber Company work crew was made up of Cherokee men recruited from nearby to work in the growing timber industry. Whiting operated a band mill in Judson, North Carolina, a small community that was submerged under Fontana Lake after the construction of Fontana Dam. Some 15 company towns and sawmills were built in the Smokies in and around the Qualla Boundary. (Courtesy of the Great Smoky Mountains National Park Archives.)

SPLITTING SHAKES. The man in this photograph holds a froe above a log and, using a mallet, will hit the log to split off shakes. Typically, shakes are used to shingle a house, forming a roof made by hand and with natural materials. A stack of finished shakes can be seen behind him at left. The man looks to be Hayes Lossiah, who worked at the Oconaluftee Indian Village. He may be making shingles for the buildings re-created for the village. (Courtesy of Cherokee Historical Association.)

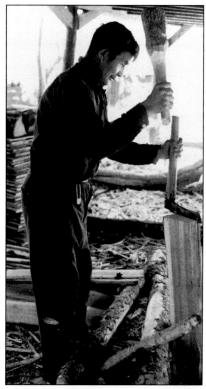

SERVICE STATIONS. If the 19th century was the age of the train, the 20th was the age of the automobile. Between 1915 and 1925, cars became available to the general public. With their growing popularity, America now needed good roads, gasoline, and service stations. By the mid-20th century, the family car put Americans on the road in record numbers. The town of Cherokee was positioned at an advantageous juncture, flanked by adjacent tourist destinations. Then as now, Cherokee was a gateway to the Great Smoky Mountains National Park and the terminus of the Blue Ridge Parkway. Service stations sprang up in Cherokee to serve the travelers. A sign at this Sinclair station advertises "tourist information." (Courtesy of Cherokee Historical Association.)

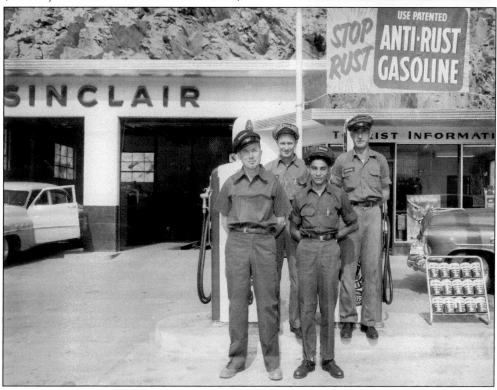

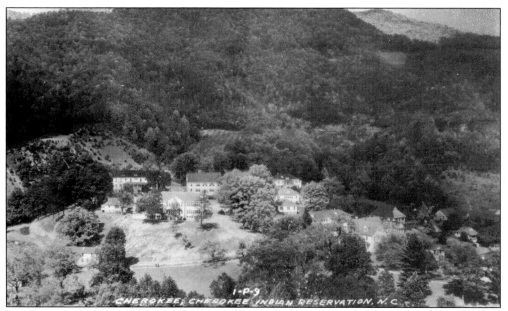

CHEROKEE BOARDING SCHOOL. This undated photograph gives a bird's-eye view of the Cherokee Boarding School campus, which opened in the late 1880s. The school was operated for its first 12 years by the Quakers; in the 1890s, it came under the supervision of the federal government. In 1954, the school was changed from a boarding school to a day school. While schooling presented opportunities for some, the boarding school experience was devastating for many. Parents were sometimes coerced into sending their children away to school. Many children spoke only Cherokee and some were punished for speaking their native tongue. (Courtesy of Andy Lett.)

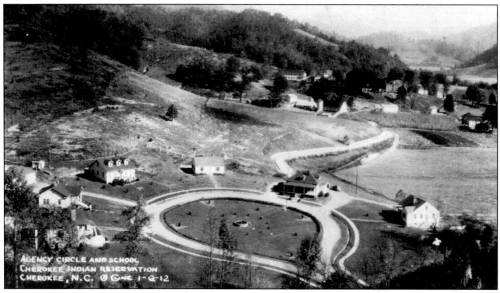

AGENCY CIRCLE. The Bureau of Indian Affairs established an office in Cherokee and built this circle of homes to house its employees. In addition to staff, the office was headed by a regional superintendent. The original location of the circle was at the intersection of Tsalagi Road and Tsali Boulevard; today, the agency office is farther down Tsali Boulevard. This postcard was made by Walter M. Cline of Chattanooga. (Courtesy of University of North Carolina at Chapel Hill.)

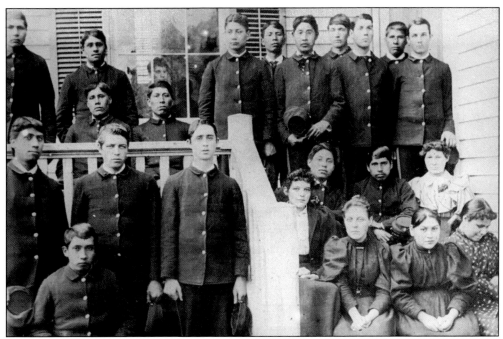

STUDENTS AT HAMPTON. Cherokee children were sent to the local boarding school, and those of high school age were often sent away to high school. This photograph, from 1895, is of a group of students newly arrived at Hampton Institute in Virginia. Hampton was originally founded to educate African American freedmen. In 1877, the school began a program for American Indians. Over 1,300 Indian students from 65 tribes attended during the following 50 years. (Courtesy of the Museum of the Cherokee Indian and the National Anthropological Archives.)

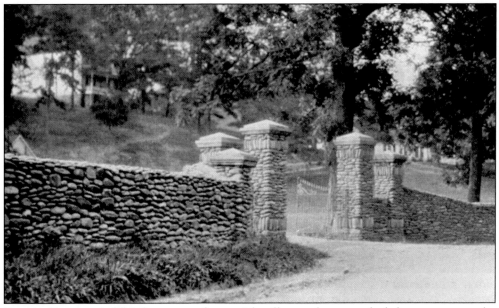

SCHOOL ENTRANCE. This long stone fence with pillars and gate marked the entrance to the Cherokee Boarding School. The photograph appeared in a 1928 publication promoting the Great Smoky Mountains National Park. (Author's collection.)

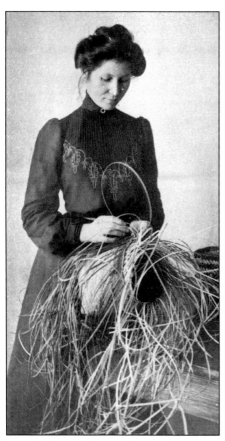

ARIZONA SWAYNEY. This photograph shows Arizona Swayney (Blankenship) making a basket. Swayney attended Hampton Institute from 1896 until 1903 and returned as a faculty member from 1904 to 1906. After the turn of the 20th century, boarding schools reversed their policies to eradicate native cultural practices and began to include native traditions in their curricula. Swaney taught basketry, pottery, and lacemaking. (Courtesy of the Museum of the Cherokee Indian.)

WOODWORKING CLASS. The 20th-century inclusion of Cherokee crafts as part of the school curriculum was a turnabout from older school policies in which schools actively (and notoriously) sought to extinguish native practices. In this photograph, Goingback Chiltoskey stands with one of his sculptures while one student makes a chair and another makes a dough bowl. Born into a Cherokee-speaking family in the Piney Grove community of the Qualla Boundary, Chiltoskie returned to Cherokee in 1935 from a stint away at school to teach until he entered the army. Married in 1956, he changed the spelling of his name from "Chiltoskie" to "Chiltoskey," noting that he gave away the "key" to his heart. This photograph was printed in the 1950 Cherokee Indian Fair program. (Photograph by Vivienne Roberts, courtesy of the Cherokee Historical Association.)

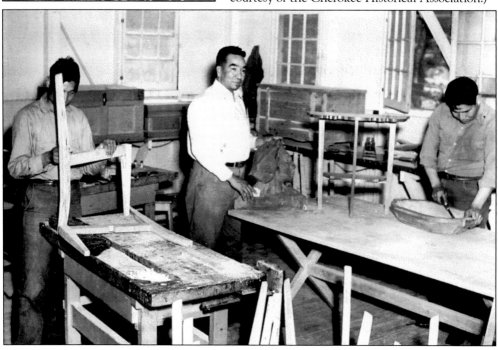

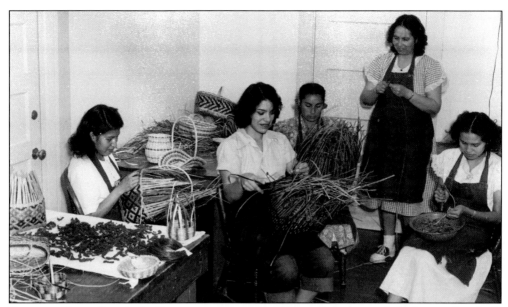

BASKETRY CLASS. Born in the Soco community, Lottie Queen Stamper taught basketry to hundreds of girls from 1937 until 1966. Stamper stands while students work on weaving rivercane baskets in a 1950s Cherokee Boarding School classroom. From left to right are Lois Rattler (Calonehuskie), Frances Bradley, Annie Queen, Stamper, and Mary Jo Washington. This photograph was printed in the 1950 Cherokee Indian Fair program. (Photograph by Vivienne Roberts, courtesy of the Museum of the Cherokee Indian.)

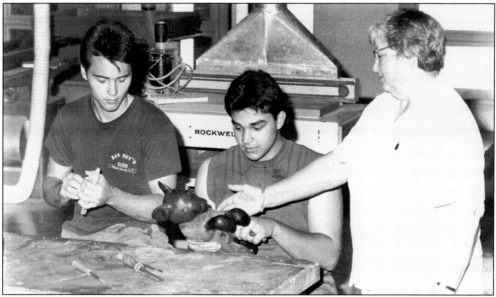

CARVING CLASS. While many Cherokee artists were self-taught or learned their craft from family, Amanda Crowe earned a professional degree from the School of the Art Institute of Chicago. After living and working away, Crowe returned to Cherokee in 1953 and set up a studio in the Painttown community. She was hired to teach at the Cherokee High School, where in a single day, she taught up to 73 students in the 10th through 12th grades. The boy at left is Joey Owle. (Courtesy of Cherokee Historical Association.)

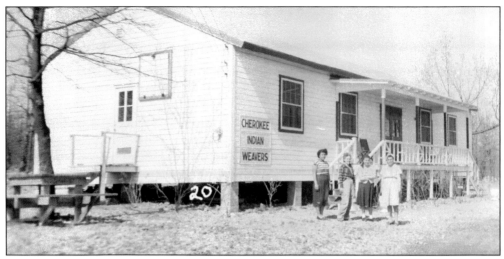

WEAVING STUDIO. In 1931, weaving was introduced into the curriculum at the Cherokee Boarding School. While craft classes were later taught by talented Eastern Band craftsmen, weaving was initially introduced by Ethel Garnett, a graduate of the influential Berea College weaving program. She built a weaving program that boasted 20 looms. The wool needed for weaving was grown locally and the spinning and dyeing were done at the Snowbird Indian School in Robbinsville. The school supplied money for salaries, but not for materials and supplies, so Garnett hosted dinners and sold craft items to support the program. This Cherokee Indian Weavers building was on the grounds of the boarding school. (Courtesy of Andy Lett.)

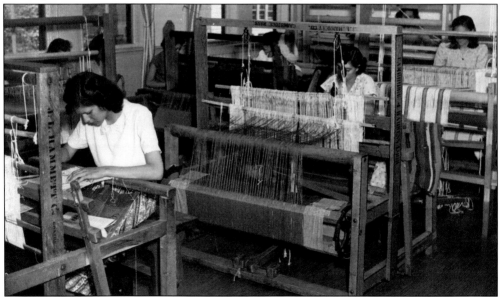

WEAVING CLASS. Although weaving was not a traditional Cherokee craft, loom weaving was taught under the umbrella of home economics. This photograph from the 1940s—a decade after weaving was introduced at the Cherokee Boarding School—shows students working at a number of floor looms. At the boarding school, regular academic classes were held in the mornings with the afternoons devoted to learning trades and home skills. For girls, these skills would have been weaving, basketry, sewing, and needlework. (Photograph by Vivienne Roberts, courtesy of the Museum of the Cherokee Indian.)

Four

COMMUNITY TRADITIONS

SEQUOYAH. While the Cherokee language has been spoken for thousands of years, its written form is only 200 years old. Sequoyah was a blacksmith and silversmith before he gained fame as the inventor of the Cherokee alphabet. Born in the Cherokee homeland in the late 1700s, Sequoyah saw that his tribe was at a disadvantage in negotiating treaties, since Cherokee could neither write nor read them in their own language. He set out to invent a system of writing that is now called the syllabary. In 1821, after 12 years of working on the new alphabet, he and his daughter introduced his syllabary to the Cherokee people. It was officially adopted by the tribe in 1825. While there are many 19th-century prints of Sequoyah's portrait, the original, painted by Charles Bird King, was destroyed by a fire that swept through the Smithsonian Castle building in 1865. (Courtesy of the Library of Congress.)

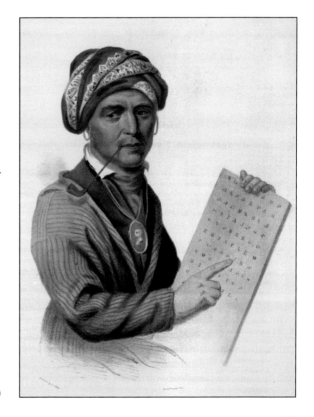

Cherokee Alphabet.

(Cherokee syllabary chart with 6 columns and rows of syllabary characters. Characters as printed, with their romanized syllable values:)

D *a*	R *e*	T *i*	Ꮼ *o*	Ꮎ *u*	i *v*
Ꮪ *ga* Ꮕ *ka*	Ꮄ *ge*	Ꭹ *gi*	A *go*	J *gu*	E *gv*
Ꮕ *ha*	Ꮅ *he*	Ꮟ *hi*	Ꮗ *ho*	Ꮦ *hu*	Ꮴ *hv*
W *la*	Ꮒ *le*	P *li*	Ꮇ *lo*	M *lu*	Ꮧ *lv*
Ꮯ *ma*	Ꮍ *me*	H *mi*	Ꮖ *mo*	Ꮩ *mu*	
Ꮎ *na* Ꮠ *hna* Ꮤ *nah*	Ꭺ *ne*	Ꮑ *ni*	Z *no*	Ꮫ *nu*	Ꮟ *nv*
Ꮖ *qua*	Ꮙ *que*	Ꮗ *qui*	Ꮼ *quo*	Ꮳ *quu*	Ꮢ *quv*
Ꮞ *sa* Ꮝ *s*	Ꮪ *se*	Ꮀ *si*	Ꮉ *so*	Ꮜ *su*	R *sv*
Ꮣ *da* Ꮤ *ta*	Ꮞ *de* Ꮦ *te*	Ꮥ *di* Ꮨ *ti*	V *do*	Ꮪ *du*	Ꮫ *dv*
Ꮭ *dla* Ꮯ *tla*	L *tle*	C *tli*	Ꮿ *tlo*	Ꮲ *tlu*	P *tlv*
Ꮳ *tsa*	Ꮗ *tse*	Ir *tsi*	K *tso*	J *tsu*	Cᵚ *tsv*
Ꮹ *wa*	Ꮺ *we*	Ꮻ *wi*	Ꮼ *wo*	Ꮽ *wu*	6 *wv*
Ꮿ *ya*	B *ye*	Ꭿ *yi*	Ꮀ *yo*	Ꮹ *yu*	B *yv*

Sounds represented by Vowels.

a, as a in father, *or short as a in* rival
e, as a in hate, *or short as e in* met
i, as i in pique, *or short as i in* pit

o, as aw in law, *or short as o in* not
u, as oo in fool, *or short as u in* pull
v, as u in but, nasalized.

Consonant Sounds

g nearly as in English, but approaching to k. d nearly as in English but approaching to t. h.k.l.m.n.q.s.w.y. as in English. Syllables beginning with g, except Ꮝ have sometimes the power of k.Ꭺ.Ꮝꮼ are sometimes sounded to, tu, tv. and Syllables written with tl except Ꮭ sometimes vary to dl.

SYLLABARY. The writing system invented by Sequoyah is called a syllabary because its sounds are represented syllable by syllable, rather than by individual letters like the English alphabet. The original syllabary of 86 symbols was penned in Sequoyah's own hand, but the characters were later modified so they could be cast into type for printing. This version of the syllabary was published in *Myths of the Cherokee*. (Author's collection.)

50

ᏣᎳᎩ ᏧᎴᎯᏌᏅᎯ

CHEROKEE PHŒNIX & INDIANS' ADVOCATE.

NEW ECHOTA, SATURDAY JUNE 11, 1831.

VOL. III — NO. 5?

JOHN CANDY

At $2.50 if paid in advance, $3 in six months, or $3.50 if paid at the end of the year.

To subscribers who can read only the Cherokee language the price will be $2.50 in advance, or $2.50 to be paid within the year.

Every subscription will be considered as continued unless subscribers give notice to the contrary before the commencement of a new year, and all arrearages paid.

Any person procuring six subscribers and becoming responsible for the payment, shall receive a seventh gratis.

All letters addressed to the Editor, Post paid, will receive due attention.

AGENTS FOR THE CHEROKEE PHŒNIX.

The following persons are authorized to receive subscriptions and payments for the Cherokee Phœnix.

Messrs. Pierce & Williams, No. 20 Market St. Boston, Mass.
George M. Tracy, Agent of the A. B. C. F. M. New York.
A. D. Eddy, Canandaigua, N. Y.
William ——, Utica, N. Y.
—— ——, ——, Charleston, S. C.
Col. George Smith, Statesville W. T.
Jeremiah Austill, Mobile, Ala.
Rev. Cyrus Kingsbury, Mayhew Choctaw Nation.
Col. William Robertson, Augusta Ga.
Col. James Tunn, Bellefonte, Ala.

From the Casket.

THE MEXICANS, IN 1830.—BY A MEXICAN CITIZEN.

(concluded.)

No. III—MEXICAN RESOURCES.

After having given in the two preceding numbers an idea of the Mexican population and politics, these sketches of the Mexican population will be concluded by a rapid survey

CHEROKEE PHŒNIX. By 1828, the Cherokee Nation was publishing the *Cherokee Phœnix*, a bilingual newspaper and the first newspaper printed in a Native language on the American continent. The *Phoenix* was first issued in what was then the Cherokee capital city at New Echota, near Dalton, Georgia. It is still published today. (Courtesy of Hunter Library Special Collections, Western Carolina University.)

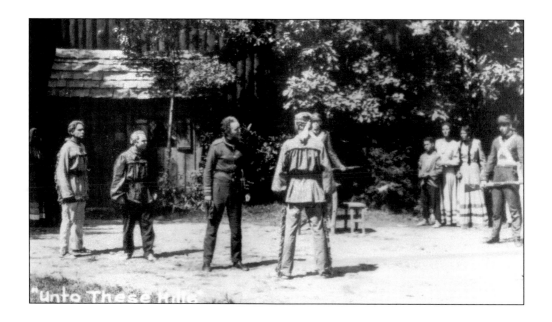

TRAIL OF TEARS. In the 1830s, the Cherokee faced their greatest trial when the entire Cherokee nation was ordered to leave its homeland. Men, women, and children walked 1,000 miles along what has come to be known as the Trail of Tears. Pres. Andrew Jackson's Indian Removal Act of 1930 legalized the forced migration of eastern tribes to Indian Territory, what is now Oklahoma. By most estimates, 16,000 Cherokees faced 200 days of hard walking. They were overtaken by winter, starvation, disease, and exhaustion, and more than 4,000 died along the way. Here, those sad events are dramatized to tell this story. (Both, courtesy of Andy Lett.)

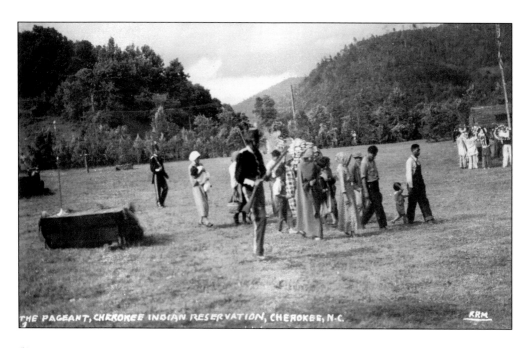

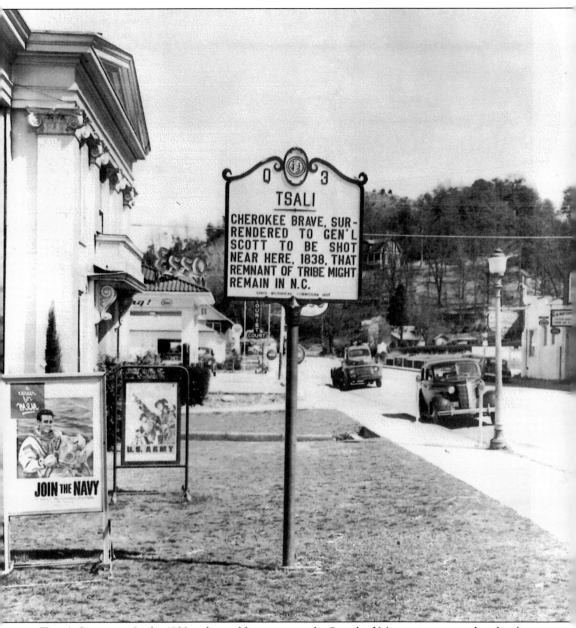

TSALI

Q 3

CHEROKEE BRAVE, SUR-
RENDERED TO GEN'L
SCOTT TO BE SHOT
NEAR HERE, 1838, THAT
REMNANT OF TRIBE MIGHT
REMAIN IN N.C.

JOIN THE NAVY

U.S. ARMY

TSALI'S SACRIFICE. In the 1830s, when soldiers came to the Snowbird Mountains to round up families for the Removal, the patriarch Tsali defended his wife from the abuse of soldiers and resisted. In the scuffle that followed, a soldier was killed. Although Tsali, his family, and others escaped, the US Army pledged to hunt them down. In exchange for his surrender, the Army abandoned its hunt for the remaining resistance. Sacrificing himself for his people, Tsali, two of his sons, and his brother were executed. To further humiliate and break the resolve of the resistance, soldiers forced other Cherokee prisoners to carry out the execution. This historical marker commemorates Tsali's sacrifice. (Courtesy of the Cherokee Historical Association.)

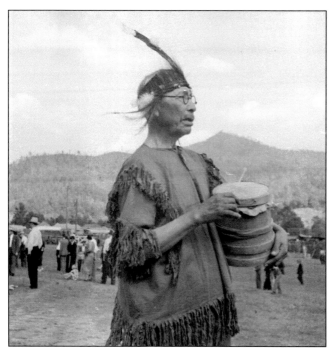

WILI WESTI. Will West Long was born in 1870 as Wili Westi. While still a young man, he became an interpreter for several ethnologists who visited the mountains. He was one of a few tribal members who worked with James Mooney, providing interpretations of stories that were recorded in *Myths of the Cherokee*. Long can be seen in the photograph below with a drum at center. He lived in Big Cove, an area often noted to be the most traditional among the Qualla Boundary communities. Besides his well-documented work with outsiders, Long was a member of tribal council for 28 years. (Courtesy of the Great Smoky Mountains National Park Archives.)

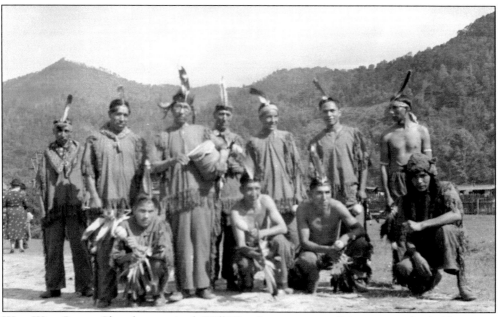

WILL WEST LONG. Cherokee patriarch Will West Long was a medicine man and tribal historian who practiced and preserved sacred medicine and ceremonial traditions. In 1912 and 1913, Long and the residents of Big Cove held a community fair that was to grow into the annual Cherokee Indian Fair. He later served as one of the directors of the fair from 1932 to 1946. An authority on traditional medicine, carving, language, music, and dance, Long was a consultant for other visiting ethnologists, among them Frank Speck. He was listed posthumously as coauthor with Speck on the book *Cherokee Dance and Drama*. This photograph was taken at the 1937 Cherokee Indian Fair. (Courtesy of the Great Smoky Mountains National Park Archives.)

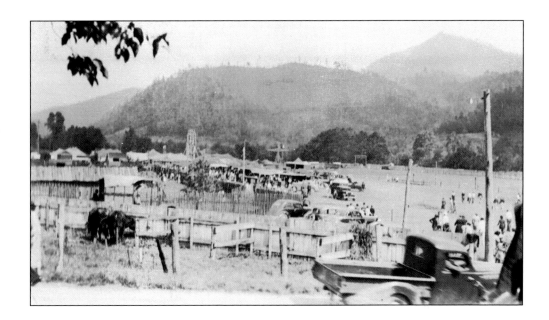

CHEROKEE INDIAN FAIR. After two years of hosting a cultural fair in Big Cove, the Eastern Band held an all-tribal event for the first time in 1914. The fair has been a popular annual event ever since. For many years, the fair was set up with rows of stockade fences that separated various activities. In the 1937 photograph above, carnival rides are barely visible in the background. In the photograph below from the 1940s, the fair has grown considerably, with a large arrangement of booths throughout the fairgrounds. In the background, a circle of onlookers line up around the ball field in anticipation of a game. The ever-popular Ferris wheel can be seen at center. In 1937, the fair was held on October 5–8. Admission was 50¢. (Both, courtesy of Andy Lett.)

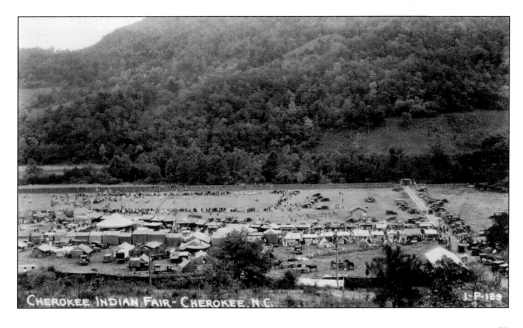

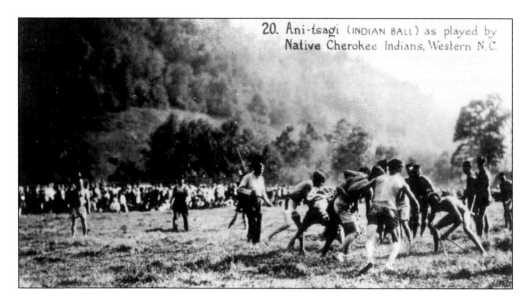

20. Ani-tsagi (INDIAN BALL) as played by Native Cherokee Indians, Western N.C.

ANI-TSAGI. Indian Ball, as it is called on this photo-card, could be the oldest ball game to be played in North America. Historically, it was as much a training exercise in physical endurance and ethics as it was a game. Known commonly as stickball, these competitions were a rite of passage and a means to settle disputes and, today, to continue to bring communities together. Stickball is sometimes referred to as the "little brother of war," given it was a no-holds-barred type of competition. In the photograph below, the team can be seen holding ball sticks. These are made from hickory and webbed with animal sinew. The ball is traditionally made of yarn and covered with hide. (Both, courtesy of Andy Lett.)

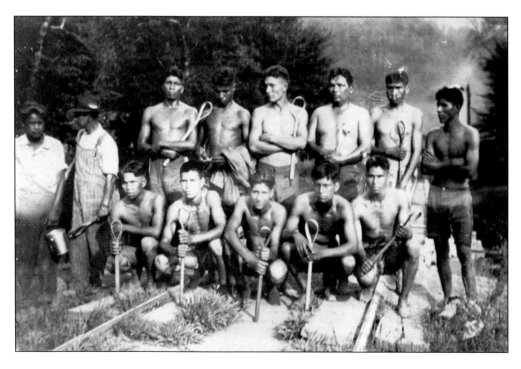

STICKBALL PLAYERS. The standing player pictured at right is Sawanugi, photographed by James Mooney in 1888 for the ethnographic study *Myths of the Cherokee*. Sawanugi holds a traditional ball stick over his shoulder. While modern readers think of stickball as a game, players took this competition very seriously. The night before, they would assemble for a spiritual dance and dip their sticks into the river for power. In the photograph below, players wait their turns. Stickball is now enjoyed by all during the annual Cherokee Indian Fair, where this picture was taken in 1948. (Right, author's collection; below, courtesy of the Museum of the Cherokee Indian.)

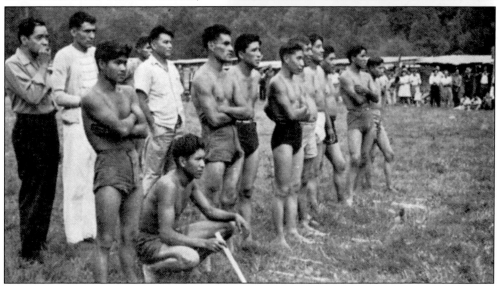

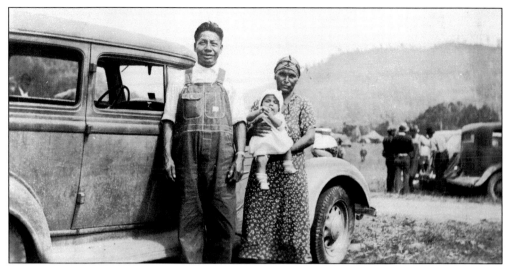

GOING TO THE FAIR. While many think of the Indian Fair as an event for outsiders to see and learn about Cherokee traditions, in reality, it is a community event celebrated by local people. Many of the competitions are between townships. In this 1937 photograph, a family stands in front of their vehicle, the man in overalls and the woman wearing a calico dress and bandana head scarf. Perhaps this family is entering their baby in the baby contest, where prizes were awarded for prettiest and fattest babies. (Courtesy of Andy Lett.)

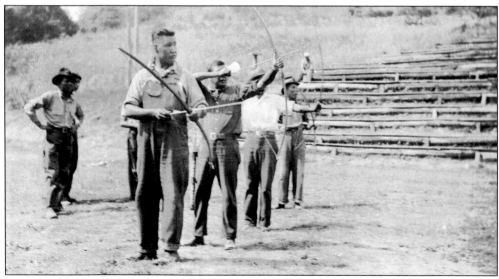

ARCHERY COMPETITION. Besides the ever-popular stickball, the fair hosts multiple competitions, including archery and blowgun contests. Prizes were awarded to the highest archery club score and highest individual score. Only members of the Eastern Band of Cherokee Indians were allowed to participate in competitions and exhibits. Here, men take their places with bows and arrows. This photograph was also taken at the 1937 fair. (Courtesy of Andy Lett.)

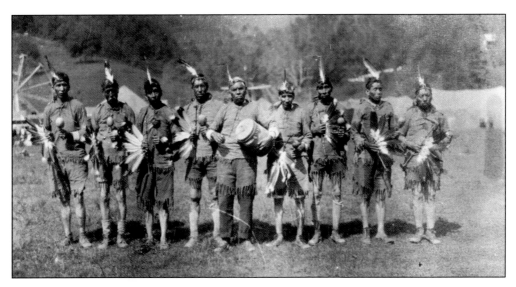

DANCE COMPETITION. While the Cherokee Indian Fair hosts competitions—of agricultural products, livestock, crafts, archery, and blowguns—the event also includes performances, as shown in both these photographs. In the undated photograph above, a group of men performs. For several years in the early 1930s, the community of Big Cove put on old-time dances. By 1932, Birdtown and Soco entered teams. By 1940, the fair program describes several dance performances, including the Green Corn Dance, Bear Dance, and Beaver Dance. The photograph below was taken in 1939 and shows dancers in front of viewers seated along the bleachers. (Above, courtesy of Andy Lett; below, courtesy of the State Archives of North Carolina.)

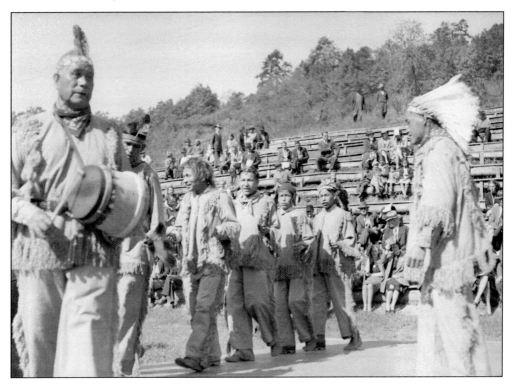

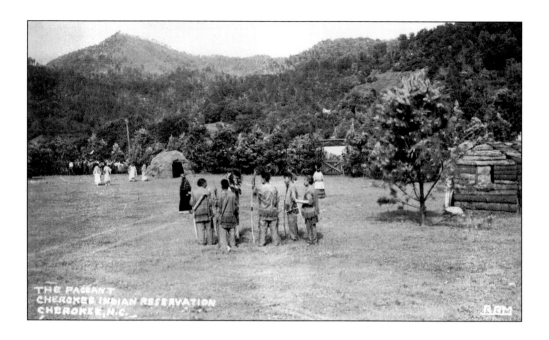

THE PAGEANT. The 1935 Indian Fair included a special pageant with 500 actors from 12 different tribes. Titled the *Spirit of the Great Smokies*, the performance depicted dramatic episodes from the story of the Cherokee. The photograph above shows the people at peace in their village, forever changed by the "great white migration" and encroachment onto their land, depicted below. The pageant was held during the fair in 1935; in 1937, it was performed three times a week for two weeks during midsummer. Many see this pageant as a forerunner to the popular drama that premiered in 1950. (Both, courtesy of Andy Lett.)

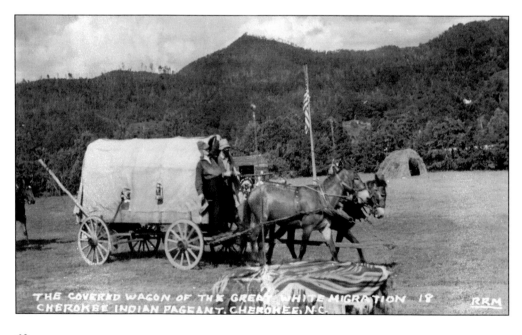

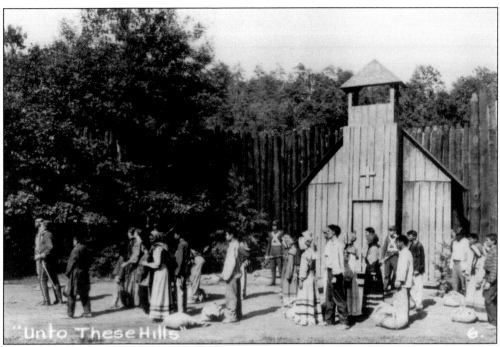

THE DRAMA. *Unto These Hills* is the region's most popular outdoor drama. The production recounts the story of the Cherokee people and their encounters with Europeans coming into their lands. The play remained the same until the first decade of the 21st century, when it was re-scripted several times to correct historical inaccuracies. In 2017, the play returned to its original rendition after a lackluster response to the newer versions. Above, Cherokee people are rounded up and held in a stockade awaiting removal to Indian Territory in the West. At right, Tsali and sons surrender. Kneeling is actor and Cherokee elder Robert Bushyhead. (Above, courtesy of Andy Lett; right, courtesy of Tom Frazier.)

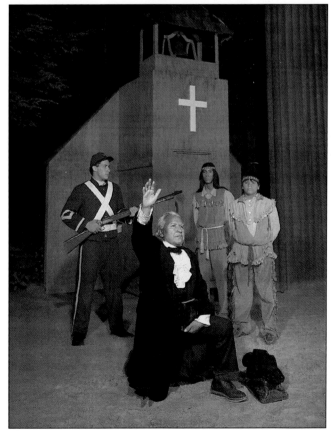

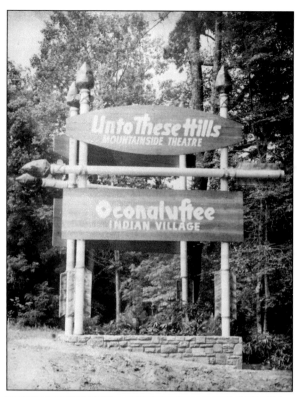

THEATER ENTRANCE. This sign announces the entrance to the Mountainside Theatre and the Oconaluftee Indian Village on the way up to Drama Road. The theater is the site of the *Unto These Hills* historical drama. Dramatic costumes and body paint have contributed to the popularity of the seasonal rendition. (Courtesy of the Cherokee Historical Association.)

EAGLE DANCE. This photograph of the opening scene of *Unto These Hills* was taken in 1952, two years after the play's initial opening. The dramatic Eagle Dance is considered one of the highlights of the performance. (Courtesy of the State Archives of North Carolina.)

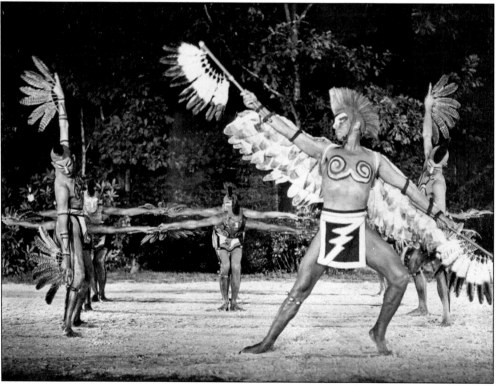

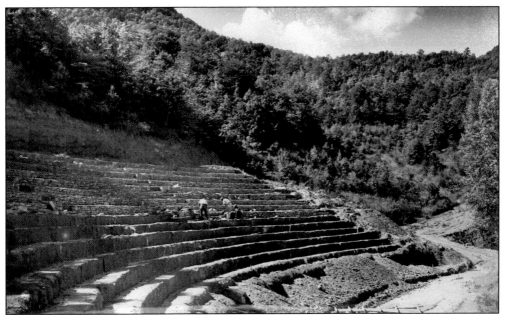

MOUNTAINSIDE THEATRE. *Unto These Hills* premiered in 1950 to wide acclaim. It has been a regular feature of Cherokee summers ever since. The annual production is held under the stars in an outdoor theater that seats 2,500. The bowl-shaped theater, built into the mountainside as its name suggests, provides excellent views and acoustics. More than six million people have seen the performance in the almost 70 years of its showing. (Courtesy of the Cherokee Historical Association.)

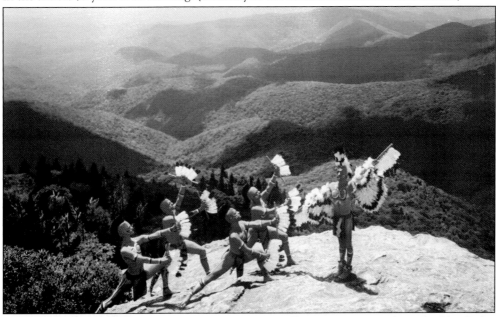

EAGLE DANCERS. Members of the cast of *Unto These Hills* pose atop a site along the Blue Ridge Parkway. The rock outcropping is known as the Devil's Courthouse; for the Cherokee, the traditional name for this site is Judaculla's Seat of Judgment. This photograph was taken in the 1980s. A cast of 40 actors puts on the play along with an additional 20 behind-the-scenes staff. Jimmy Bradley (right) was the first Cherokee actor to play the Eagle Dancer. (Courtesy of Tom Frazier.)

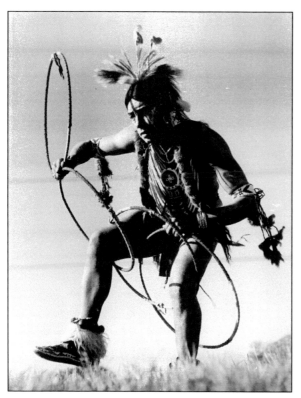

HOOP DANCER. Unlike group dances, such as the Corn and Eagle Dance, the hoop dance is performed by an individual. It is a storytelling dance and, to some, a healing dance. The hoops represent the circle of life and how everything in life is connected. Like the hoop, life is a circle: birth to death, spring to winter. (Courtesy of the Cherokee Historical Association.)

CLOGGING. While this type of dance is not typical of Cherokee, clogging is common throughout the southern Appalachians. It is a type of step dance in which the dancer strikes the floor to create a rhythm. While clogging is sometimes called buck dancing, in the latter dance, dancers keep their bodies immobile and their steps low to the floor. Both types of dances are done to fiddle music. (Courtesy of Andy Lett.)

Five

WORK BY HAND

PRESERVING ARTIFACTS. These artifacts, saved and displayed on a porch belonging to Will West Long, include several craft and dance objects. Clockwise from top left are clothing, feathered dance wands, a two-person saw, a mask, walking sticks, a carving, a pottery vessel, two chairs that look to have woven bottoms, a wooden dance drum, two mask blanks, a bow with arrows, and a small gourd rattle. The 1932 photograph is included in *Smithsonian Bulletin* 133 from 1943. (Courtesy of the Museum of the Cherokee Indian.)

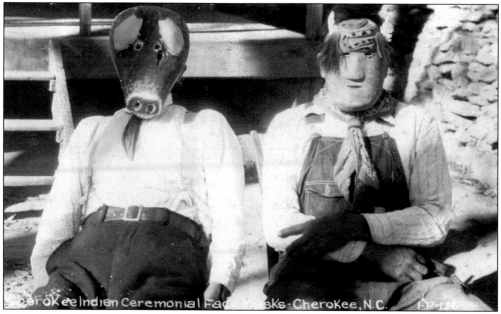

WEARING MASKS. Masks are an integral part of Cherokee culture and are used in ceremonial dances. Masks sometimes represent animals and sometimes human faces. Mostly carved from wood, masks can also be made from leather or hornets' nests. While people buy masks to hang on their walls today, traditionally they were worn for ceremonies and dances. The mask at left is a buffalo mask; at right is a warrior or healing mask, distinguished by a snake coiled on top of the head. (Courtesy of Andy Lett.)

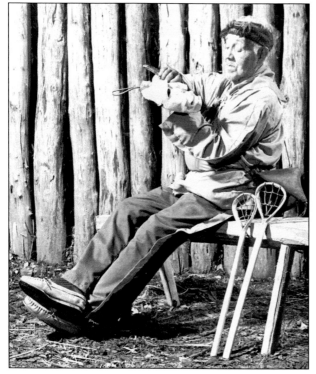

CARVING A MASK. Not much is known about Sim Jessan despite the fact that he was an accomplished carver. Jessan worked for many years at the Oconaluftee Indian Village, where he is pictured here carving a mask. A pair of ball sticks is leaned up against his bench. (Courtesy of the Cherokee Historical Association.)

CARVING SPOONS. Also seen at the Oconaluftee Indian Village, James Conseen is carving wooden spoons and ladles. Originally, carving was a skill necessary for making functional items used in the home such as these. Today, these same skills turn out work purchased by visitors as souvenirs of their visit. (Courtesy of the Cherokee Historical Association.)

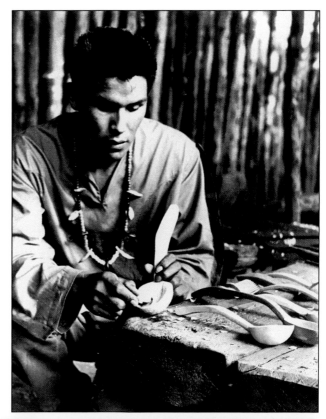

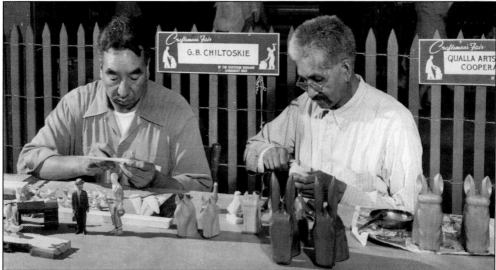

CARVING AT THE FAIR. Brothers Goingback and Watty Chiltoskie were two of Cherokee's most well-known carvers. Here, they demonstrate at the 1952 Craftsman's Fair of the Southern Highlands in Asheville, North Carolina. According to a small sign behind them, the pair represent the Qualla Arts and Crafts Mutual cooperative. On the table in front of them are carvings of figures made by Goingback and horsehead bookends produced by Watty. (Courtesy of the Southern Highland Craft Guild Archives.)

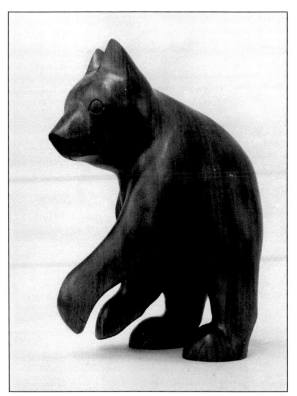

CARVED BEAR. Amanda Crowe carved so many bears that she once quipped, "Everybody in the country must have one of my bears." Well-traveled and university educated, Crowe returned to Cherokee in 1953 and taught carving to high school students. While she designed and produced many different animals, the bear remained her signature piece. (Courtesy of Qualla Arts and Crafts Mutual Inc.)

BEAR ENCOUNTER. A family traveling near Cherokee in the 1950s encounters a bear crossing the road. While not an everyday occurrence, seeing a bear is still something that causes cars to stop and visitors to rush for their cameras. (Courtesy of the Cherokee Historical Association.)

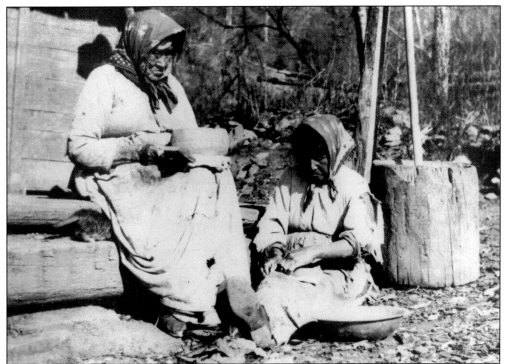

KATALSTA AND HER DAUGHTER. While pottery is a traditional craft and continues to be popular today, there were few potters left in North Carolina after the Removal. These two potters, photographed by James Mooney in the 1880s, are Katalsta (left) and her daughter Iwi Katalsta. Katalsta said she could trace her pottery lineage back three generations. (Courtesy of the Museum of the Cherokee Indian.)

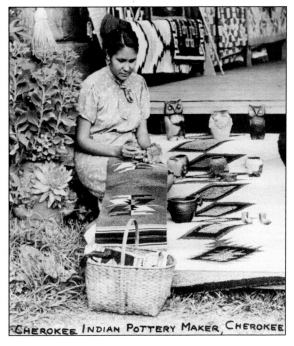

BIGMEAT POTTERY. Because pottery required specialized skills, the tradition often passed within families. Ethel Bigmeat Queen—shown here with her wares—was the second daughter of Charlotte Welch Bigmeat. The family pottery tradition continues with Queen's grandson Joel Queen, who produces pottery in Cherokee today. Over the years, Bigmeat family pottery has remained a signature craft on the Qualla Boundary. (Courtesy of the University of North Carolina Library at Chapel Hill.)

CHEROKEE INDIAN POTTERY MAKER, CHEROKEE

STRIPPING BARK. Before the advent of metal and plastic, people in all cultures depended upon natural materials to make the things that they needed. Clay, wood, stone, shell, copper, mica, plant fibers, and animal hides were used in many ways. Before weaving a basket, its maker must first dye the weaving materials. Harvesting and preparing native roots and bark is a separate process that requires an extensive knowledge of plants and their habitats. Here, renowned basket maker Emma Taylor gathers walnut bark as a dye material in preparation for making a basket. (Courtesy of Qualla Arts and Crafts Mutual Inc.)

GATHERING BLOODROOT. With a process intimately tied to the land, Cherokee makers use native plants to weave and dye baskets. Four plants native to the western North Carolina mountains form the color palette of basket weavers. Here, Helen Bradley gathers bloodroot, a white flowering plant whose root oozes red, resembling blood and giving the plant its name. (Courtesy of the Cherokee Historical Association.)

DYEING HONEYSUCKLE. Walnut, bloodroot, butternut, and yellowroot are used for color. Walnut gives weaving splits a brown color, while bloodroot produces an orange. Yellowroot is sometimes used to produce a bright yellow, and butternut makes a deep brown that is almost black. Here, Lucy George dips honeysuckle vine into a dye bath. (Courtesy of Qualla Arts and Crafts Mutual Inc.)

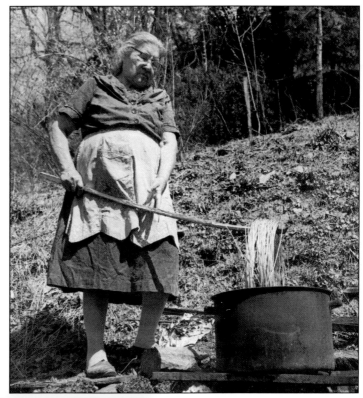

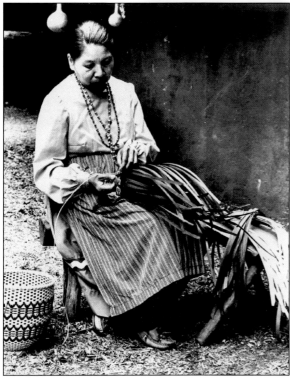

WEAVING A BASKET. Preparing basket materials, whether cane, white oak, honeysuckle, or maple, involves several steps—cutting, splitting, peeling, trimming, and dyeing. All of this must be completed before weaving can begin. The process of making a basket may be a matter of days or weeks. When looking at the price of a Cherokee basket, it is worth considering the time it took to harvest the materials, prepare them, gather the dye plants, and color the splits. Only after all these steps are complete can a basket maker begin the time-consuming process of actively weaving a basket. Here, Dinah George begins to weave. (Courtesy of the Cherokee Historical Association.)

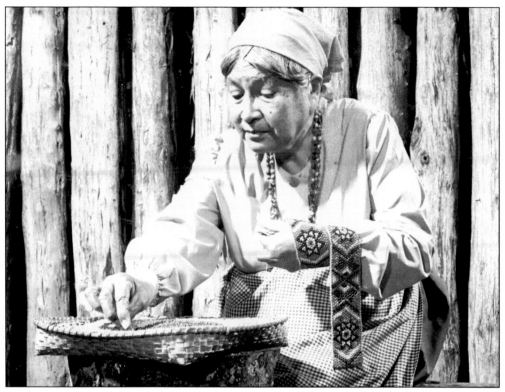

BEADING. Martha Owle is demonstrating beading at the Oconaluftee Indian Village using colorful glass beads. Beading is sometimes done freehand and sometimes on a loom. A finished beaded sash is draped over her arm. (Courtesy of the Cherokee Historical Association.)

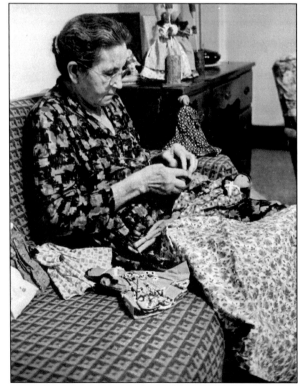

MAKING A DOLL. In every culture, dolls and toys have long been made for children. Here, Minda Sneed works on a sewn and stuffed doll. Other materials used for doll making are cornhusks and dried apples. (Courtesy of the Cherokee Historical Association.)

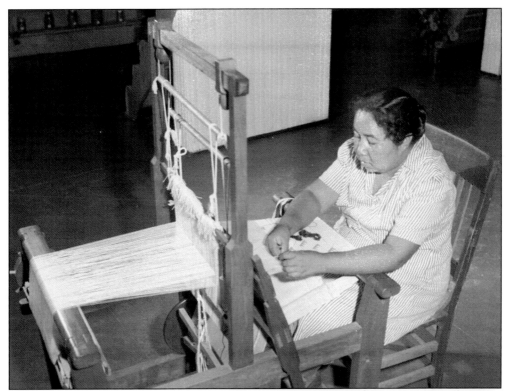

WEAVING. Spinning and weaving were necessary household skills up into the 20th century, when commercial cloth became more widely available. The woman above, pictured in the mid-1940s, is weaving on a small loom. Mary Shell, at right, is demonstrating finger weaving, a type of weaving that is more traditionally Cherokee. Finger weaving is a type of braiding that results in colorful sashes and belts, wall hangings, and small blankets. (Above, photograph by John H. Hemmer, courtesy of the State Archives of North Carolina; right, courtesy of the Cherokee Historical Association.)

MOCCASINS FOR SALE. Another popular sewn item are moccasins. Here, a sign advertises their sale in several styles made from deerskin and elk leathers. For many years, a business simply called The Cherokees made and sold souvenir-type moccasins. With recent research from the Museum of the Cherokee, more authentic moccasins are being made today by artisans of the Qualla Arts and Crafts cooperative. These include hand-stitched, pucker-toe moccasins. (Courtesy of the Cherokee Historical Association.)

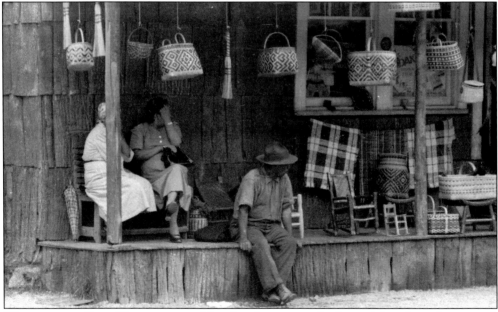

WEAVINGS FOR SALE. There are several handmade items on display and for sale at this store. A number of baskets are hanging, including a white oak egg basket and many patterned rivercane baskets. Below them are a number of plaid weavings and small chairs. This building is the Old Cherokee Trading Post, once located between the post office and Brownings Craft Shop on Tsalagi Road in the heart of Cherokee. (Courtesy of Andy Lett.)

RUGS FOR SALE. Rug making was not practiced widely on the Qualla Boundary or in western North Carolina, but there were some rugs made and sold. Three varieties of handmade rugs included hooked, woven, and rag rugs. In this photograph from 1940, several hang in front of a store. At far right are two woven coverlets. (Courtesy of the Great Smoky Mountains National Park Archives.)

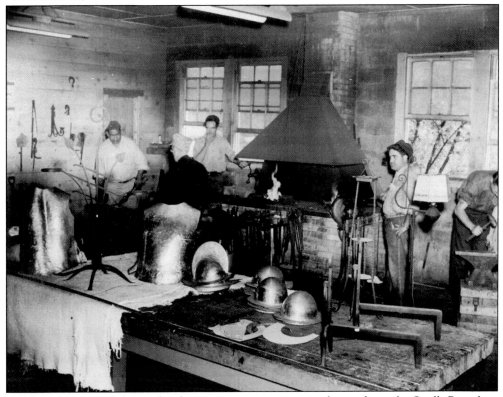

WORKING METAL. While metalworking was not as common as other crafts on the Qualla Boundary, there were times when metalworking was practiced. This blacksmith shop was set up in the Cherokee High School where a group of men made armor for the *Unto These Hills* drama. (Courtesy of the Cherokee Historical Association.)

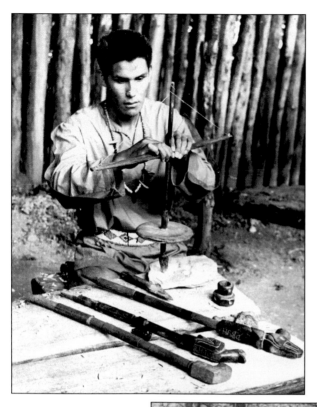

MAKING FIRE. James Conseen is demonstrating at the Oconaluftee Indian Village. He is using a bow drill, the tip causing enough friction to start a fire. In front of Conseen are a number of carved stone pipes. (Courtesy of the Cherokee Historical Association.)

MAKING A CANOE. Before the 19th century, travel was often by water. While large ships crossed oceans, here in the mountains, people used canoes to navigate the region's network of rivers. The first step in making a canoe is selecting and felling a tree, then a fire is started within a carved depression. This burns out the softer heartwood, hollowing out and hardening the walls of the canoe. (Courtesy of the Cherokee Historical Association.)

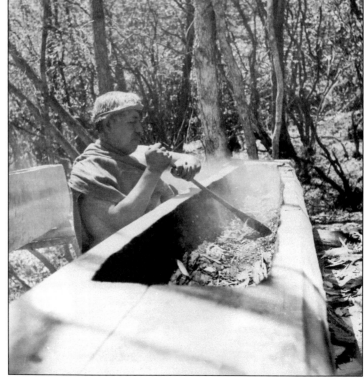

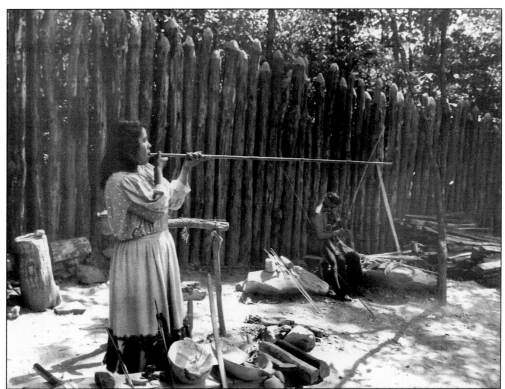

SHOOTING A BLOWGUN. While blowguns were traditionally used to hunt small game, today, they continue to be used in competitions that demonstrate accuracy and skill. Here, Winnie Scott French demonstrates the use of a blowgun at the Oconaluftee Indian Village. The blowgun itself is made from a length of cane that has been straightened and hollowed. It takes a deep breath to propel a dart to its target. (Courtesy of the Cherokee Historical Association.)

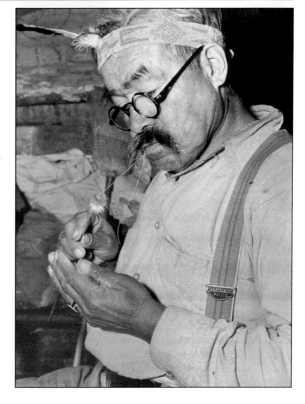

MAKING DARTS. Blowguns are still made by Cherokee people and the skill of making them is preserved and shared. The darts used in blowguns are made from thistle down. After many thistle heads are harvested and dried, they are bound together with twine or sinew. This man is shown tying off the thistle down at the end of a dart. Once a dart is complete, it is shot through a hollowed-out length of rivercane. (Courtesy of Andy Lett.)

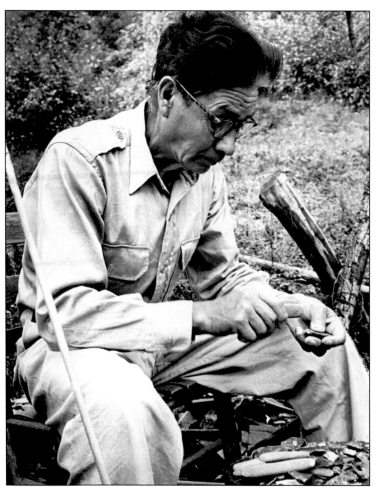

MAKING AN ARROWHEAD. Traditionally, larger game was hunted with bows and arrows. Julius Wilnoty (left) demonstrates the making of an arrowhead from flint. Archery was a skill that required a steady hand and focus. During the tourism boom in the mid-20th century, visitors (below) could try their hand at this sport. (Left, courtesy of the Cherokee Historical Association; below, courtesy of Andy Lett.)

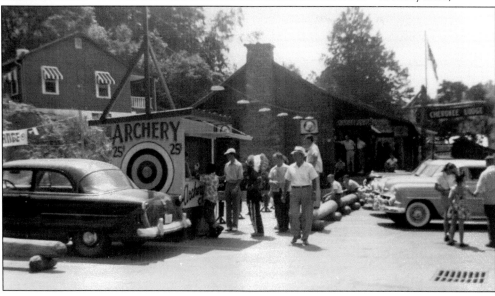

Six

KEEPERS OF CULTURE

A POTTER'S HOME. Before the creation of a tribal arts and crafts guild in the 1940s, Cherokee artisans either carried their work to neighboring resort towns or sold directly from their homes. Basket weavers walked into Cherokee or Waynesville to sell baskets, covering distances up to 50 miles. This 1940s-era photograph shows the home of Maude Welch, a renowned Cherokee potter. A sign in the front of her house reads, "Indian Pottery Made/Sold Here." (Photograph by Vivienne Roberts, courtesy of the Museum of the Cherokee Indian.)

SOUVENIR SHOPS. With the opening of the Blue Ridge Parkway and the Great Smoky Mountains National Park in the 1930s, tourists began to discover the cultural wealth of Cherokee. Visitation boomed and continues today. Several shops opened to sell souvenirs to visitors. Like the full-feathered headdresses sometimes worn by local "chiefs," not all of the items for sale were authentically Cherokee, such as the tufted bedspreads hanging on the line at right below. (Both, courtesy of Andy Lett.)

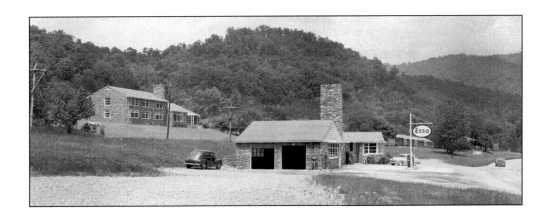

AN ARTISAN COOPERATIVE. In 1946, Qualla Arts and Crafts Mutual was formed to create a year-round market for craft sales and preserve the heritage of the Cherokee. Over 50 charter members joined the group. In 1949, the cooperative moved to a small storefront shared with a gas station in front of the Boundary Tree Motor Court (above). There were plans for Cherokee artisans to make the furnishings, drapes, and rugs for the interior of the Boundary Tree (below). (Both, courtesy of the State Archives of North Carolina.)

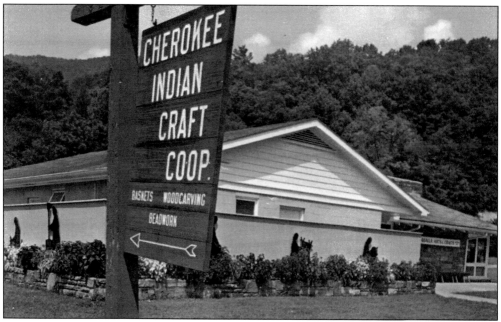

CHEROKEE INDIAN CRAFT SHOP. In 1960, Qualla Arts and Crafts Mutual moved its operation into a new building. In 1976, the current building was renovated using native stone and natural wood and a new gallery was added. In 1989, the cooperative was expanded yet again to the site seen today. That building includes an open retail space, members' gallery, storage, classroom space, archival storage, and a significant permanent collection. (Courtesy of the Museum of the Cherokee Indian.)

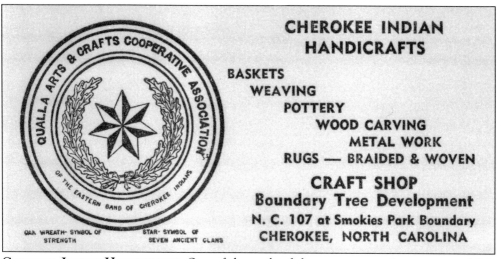

CHEROKEE INDIAN HANDICRAFTS. One of the goals of the new cooperative was to establish standards for craft products that would demonstrate authenticity. From its earliest days, the Qualla Arts and Crafts cooperative created a logo and tag to authenticate the crafts sold in its shop. This tag dates from 1949. (Courtesy of Qualla Arts and Crafts Mutual Inc.)

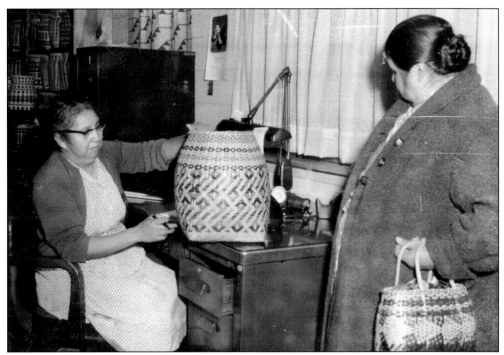

BUYING CRAFTS. Gertrude Flanagan served as the co-op's first manager, from the 1940s into the 1950s. At left above, Cecilia Taylor, herself a weaver, began as manager in 1959. Here, she is buying a large rivercane basket from Lizzie Youngbird. Betty DuPree, at left below, came on board in 1972 and remained as manager for 24 years, retiring in 1997. Before she left, Qualla Arts celebrated its 50th anniversary with 300 members. (Both, courtesy of Qualla Arts and Crafts Mutual Inc.)

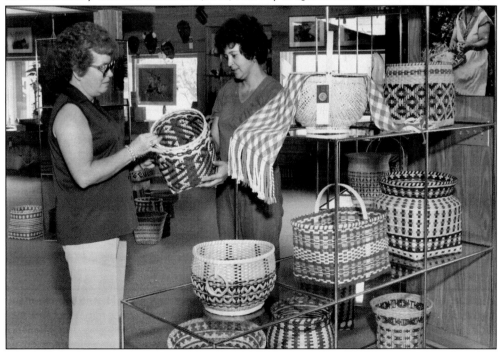

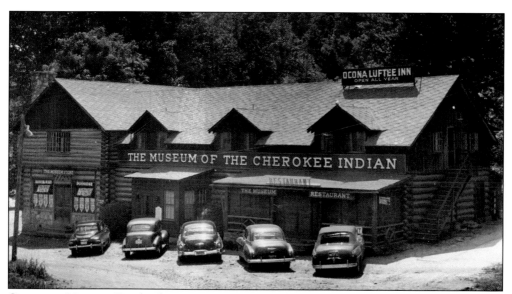

CHEROKEE MUSEUM. Besides the artisan cooperative, the Eastern Band of Cherokee established a number of other organizations to help ensure a more balanced interpretation of their heritage. In 1948, the Museum of the Cherokee Indian first opened its doors. In 1950, the Cherokee Historical Association launched *Unto These Hills*. The Oconaluftee Indian Village, a living history site, opened in 1952. The original museum building, show here, was in town. A much larger museum campus is today located on Tsali Boulevard across from Qualla Arts and Crafts Mutual. (Courtesy of the Museum of the Cherokee Indian.)

CHEROKEE FRIENDS. The Cherokee Preservation Foundation launched the Cherokee Friends, a group of well-trained cultural ambassadors, to help visitors explore and experience the tribe's rich heritage. Headed by Mike Crowe (left front) in 2015, the program came under the auspices of the Museum of the Cherokee Indian. Dressed in the Cherokee style from the 1700s, the Cherokee Friends engage with visitors and answer their questions. They are selected for their ability to work with the public and share their cultural knowledge. Here, they pose in front of the museum. (Courtesy of the Museum of the Cherokee Indian.)

FESTIVALS. The Museum of the Cherokee Indian hosts a number of festivals throughout the summer and fall seasons. At right, Richard Saunooke demonstrates beading at the annual Cherokee Voices festival. Below, Diamond Brown is dressed in full regalia for the Festival of Native Peoples. Fading Voices is an annual festival held in the Snowbird community in nearby Robbinsville. Both photographs were taken at festivals in the summer of 2010. (Both, author's collection.)

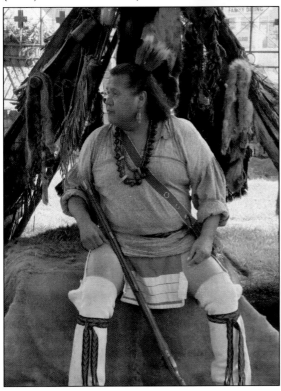

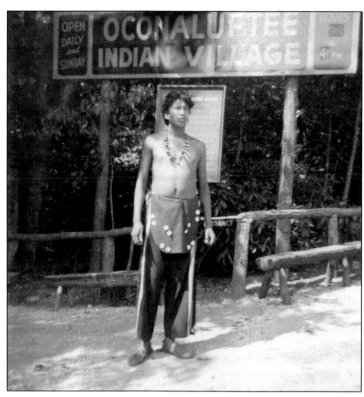

INDIAN VILLAGE.
Opened in 1952, the
Oconaluftee Indian
Village is a recreation
of 18th-century life.
In the photograph at
left, longtime village
interpreter Richard
Geet Crowe stands
at the entrance
in 1750s-era dress.
Below, Hayes Lossiah
demonstrates the art
of making darts for
blowgun competitions
at the village. (Left,
courtesy of Andy
Lett; below, courtesy
of the Cherokee
Historical Association.)

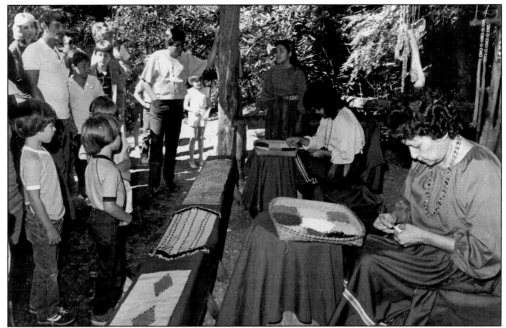

DEMONSTRATIONS. At the Oconaluftee Indian Village, interpreters wear period costumes and demonstrate a variety of traditions, including basketry, pottery, beading, finger weaving, carving, and more recently, metalworking. Here, women demonstrate beading while visitors look on. (Courtesy of the Cherokee Historical Association.)

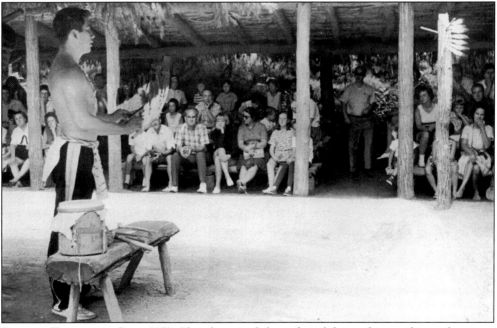

SHARING TRADITIONS. Since 1952, Cherokee people have shared their culture with outside visitors through programs and demonstrations at the Oconaluftee Indian Village. Here, an interpreter talks with a group of visitors about cultural traditions. He holds a feathered wand, and beside him is a wooden drum. (Courtesy of the Cherokee Historical Association.)

PARADE. Every fall, the Cherokee Indian Fair kicks off with a parade through town. Various community groups and organizations participate. Here, a group of cyclists wears T-shirts reminding parade goers to "Remember the Removal." A dozen cyclists typically participate in the annual event that retraces the 1,000-mile walk made by Eastern Cherokees in 1838. The first such ride was held in 1984. This photograph was taken at the 2012 parade. (Author's collection.)

YONA. Visitors are greeted by a number of life-sized bears throughout the town of Cherokee. The word for "bear" in Cherokee is *yona*. This one, in front of the Museum of the Cherokee, is dedicated to Sequoyah, inventor of the alphabet. On its back are a few of the 86 symbols that form the complete syllabary. The bear wears a turban and smokes a pipe similar to one shown in the painting of Sequoyah seen on page 49. (Author's collection.)

Seven

DESTINATIONS

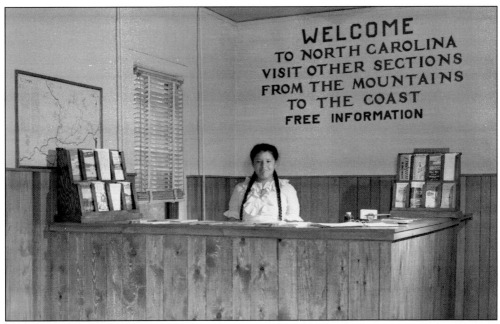

WELCOME CENTER. Early in the 20th century, before familiar destinations were established, Qualla Boundary had few visitors. The construction of the railroad through the region in the 1890s brought outsiders to western North Carolina, but few tourists. It was not until the advent of automobile travel that the region started to see outside visitors in numbers. The 1930s brought the building of the Blue Ridge Parkway and the Great Smoky Mountains National Park. The 1940s and 1950s saw the creation of many of the cultural destinations still enjoyed today. In this 1947 photograph, a young woman greets visitors at the Cherokee Information Center. (Courtesy of the State Archives of North Carolina.)

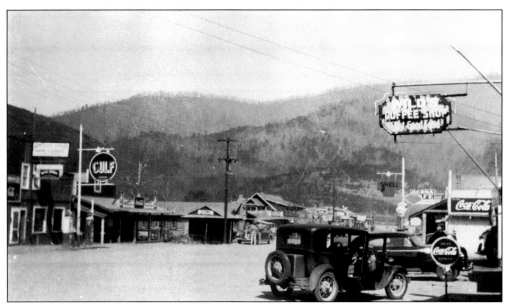

COMING TO TOWN. Cherokee was a rather quiet village until the opening of the Great Smoky Mountains National Park in 1934. As the 20th century progressed, more and more people traveled by car. With the park on its boundary, visitors spilled over from the Smokies into town. With an increase in automobiles, tourism grew steadily. These two photographs show views along Tsalagi Road in the early 1940s. (Above, courtesy of Andy Lett; below, courtesy of the Cherokee Historical Association.)

Cherokee Indians - Cherokee, N.C. I-P-78

HOLLYWOOD INDIANS. Many of the earliest attractions were patterned after Hollywood Westerns rather than authentic native traditions. Cherokee people did not live in teepees, nor did they wear full-feathered headdresses, like those pictured in these postcards. Still, this Hollywood version of Indian life was sometimes served up to tourists. Today, the tribe supports research programs that feature more authentic representations of Cherokee life. (Above, courtesy of the University of North Carolina Library at Chapel Hill; below, courtesy of Andy Lett.)

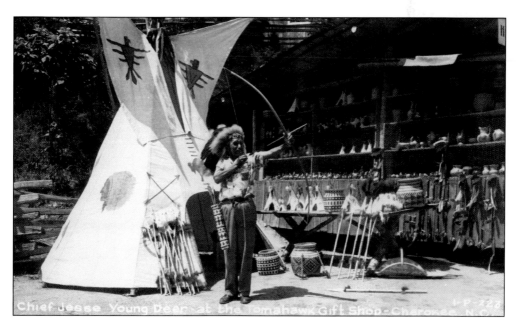

Chief Jesse Young Deer at the Tomahawk Gift Shop - Cherokee, N.C. I-P-228

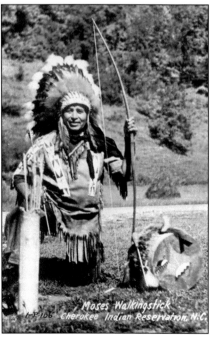

CHIEFING. Visitors to the Qualla Boundary in the 1940s and 1950s expected to find "wild" Indians roaming the "reservation." Cherokee performers did not disappoint and often dressed and posed wearing inaccurate, yet popular, garb (above). The postcard of Moses Walkingstick (left) shows him in full "chiefing" gear. To fulfill visitor expectations during the heyday of tourism, Cherokee performers dressed in headdresses typically worn by Plains Indians and never by the Eastern Cherokee. (Both, courtesy of Andy Lett.)

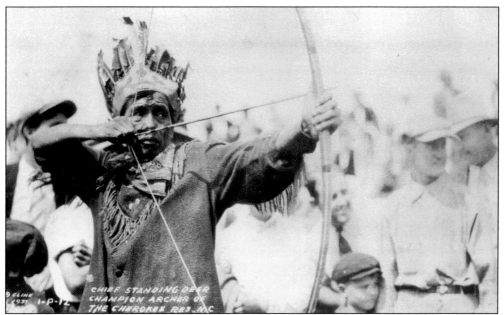

ARCHERS. The postcard above, produced by W.M. Cline, shows Chief Standing Deer with an arrow and drawn bow. The postcard names him as a "champion archer." Noyah Arch (right) strikes a similar pose in front of the Pow-Wow Indian Traders. Neither headdress is authentic to the Cherokee. (Both, courtesy of Andy Lett.)

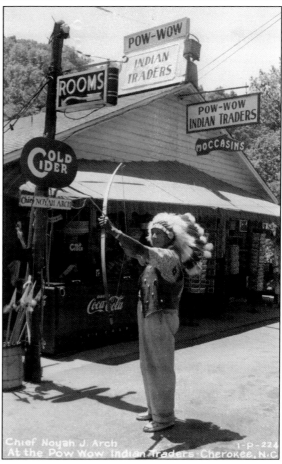

"CHIEF CAIN SCREAMER"
CHEROKEE INDIAN RESERVATION
— NORTH CAROLINA —

CLINE
1-P-40

CHIEF SAUNOOK OF THE
EASTERN CHEROKEE TRIBE
AT RED WING CRAFT SHOP
CHEROKEE N.C.

INDIAN "CHIEFS." Another Cline postcard, above, features a dramatic portrait of "Chief Cain Screamer." In the photograph at left, Chief Saunook beats on a drum in front of the Red Wing Craft Shop. While the Eastern Band of Cherokee Indians is most certainly headed by a principal chief, the men featured on postcards did not hold that elected office; instead, the title was used to enhance the visitor experience. (Both, courtesy of Andy Lett.)

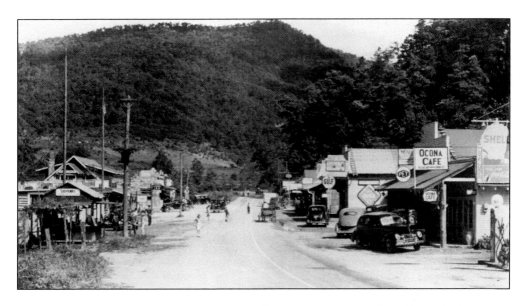

MOUNT NOBLE. The easiest way to gain one's bearings in Cherokee is by sighting the distinctive profile of Mount Noble in the distance. The mountaintop is seen at the end of Tsalagi Road, the main strip through town. A sign for the Ocona Café is on the right side of the road above. In the distance below is the distinctive arrowhead sign of the Cayuga. Boasting gifts and souvenirs, the business was owned by Hugh Lambert. In both photographs, the road is lined with tourist shops, restaurants, and attractions. Today, some of the oldest buildings remain, but are hard to recognize due to renovations and additions. In the distance, Tsalagi Road continues, crossing the Oconaluftee River bridge and becoming US 19 heading toward Bryson City. Crowning the scenes is the peak of Mount Noble. (Above, courtesy of Hunter Library Special Collections, Western Carolina University; below, courtesy of Andy Lett.)

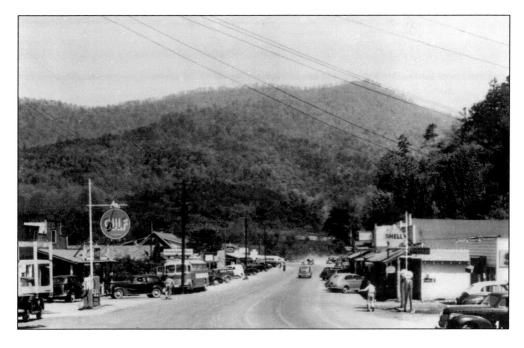

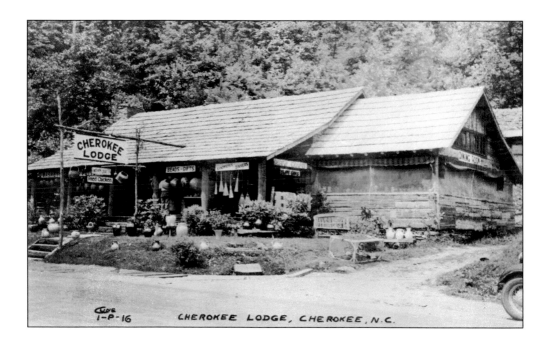

CHEROKEE LODGE, CHEROKEE, N.C.

CHEROKEE LODGE. These two photographs and those on the following page show Lloyd's Cherokee Lodge at different times in its history. All four show the building hung with a number of items for sale. The earliest photograph seems to be the one in the postcard above. The postcard below shows the building not too much later, with the bushes grown and the sign replaced. Both postcards are by W.M. Cline of Chattanooga, who produced and sold postcards of sites throughout the South. (Both, courtesy of Andy Lett.)

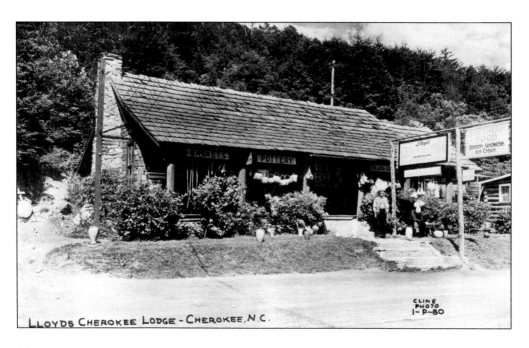

LLOYDS CHEROKEE LODGE - CHEROKEE, N.C.

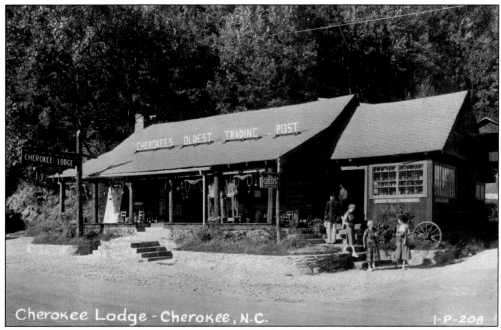

Cherokee Lodge - Cherokee, N.C.　　　　I-P-208

"OLDEST TRADING POST." The later picture of Lloyd's Cherokee Lodge above has improvements to the stairway, a new roof, and new sign. While the place does not look much like a lodge, a sign indicates that guests are welcome to enter through the gift shop. Although the business advertises itself as "Cherokee's Oldest Trading Post," not much that is visible looks authentically Cherokee. Instead, there are horse yokes and wagon wheels out front, glass in the showroom window, and a sign offering honey for sale. While it is not known when Lloyd's first opened, it is mentioned—with only four other shops—in an article from 1934. A modernized World War II–era Lloyd's (below) advertises refreshments, sandwiches, cottages, and free park maps. (Above, courtesy of Andy Lett; below, courtesy of the University of North Carolina Library at Chapel Hill.)

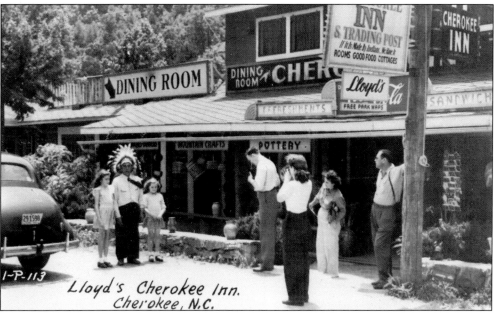

I-P-113　　Lloyd's Cherokee Inn.
Cherokee, N.C.

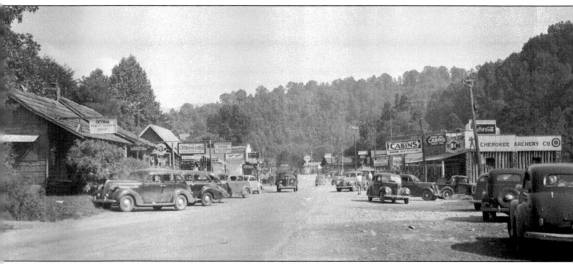

Tsalagi Road. This almost-panoramic photograph is of Tsalagi Road, in a view looking away from Mount Noble. The Ocona Beauty Shop is on the left. A bit farther on the same side of the road and marked by a large sign is Lloyd's Cherokee Lodge and next to it is the Reservation Craft Shop. Next along the left side of the road are the post office, Old Trading Post, and Brownings Craft Shop. On the right at the far end of the road are the Archery Trading Post and, front right, the Cherokee Archery Company. Lots of signs advertise food, drink, souvenirs, and gas. (Courtesy of the Great Smoky Mountains National Park Archives.)

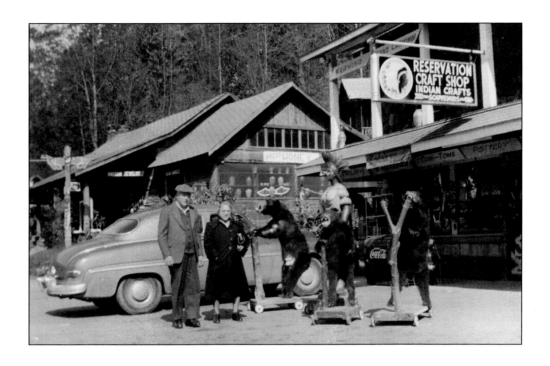

RESERVATION CRAFT SHOP. This shop was the stopping point for many tourists who wanted to pose with the stuffed bears out front (above). The storefront (below) advertises "tom-toms, pottery, moccasins, jewelry, bead-work, bows & arrows." Postcards are available from several racks at the entrance. In both photographs, Lloyd's Cherokee Lodge is visible at left. (Both, courtesy of Andy Lett.)

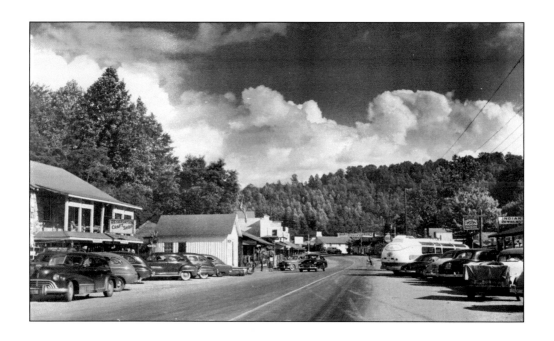

VIEW TO THE SOUTHEAST. These two photographs were taken with Mount Noble behind the photographer. The sign for the Reservation Craft Shop can be seen at left above. The small white building midway down the road is the post office. Next to it is Brownings Craft Shop and farther down is the Ocona Café. A banner announcing the Cherokee Indian Fair hangs across the road and a Smoky Mountains tour bus is parked on the opposite side. Below, the Cayuga Trading Post and the Cherokee Scout are on the right. (Both, courtesy of the Museum of the Cherokee Indian.)

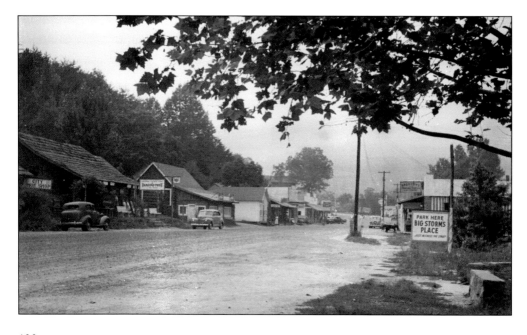

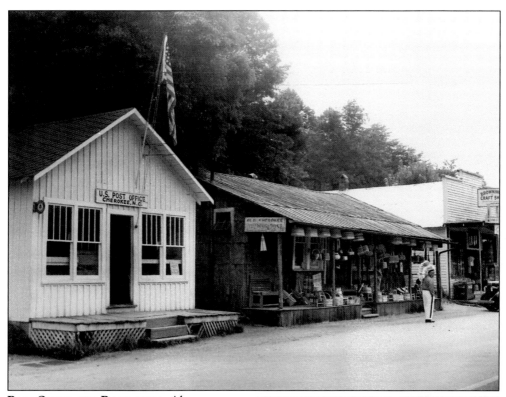

POST OFFICE AND BROWNINGS. Above, three buildings along Tsalagi Road are the Cherokee Post Office, Old Trading Post, and Brownings Craft Shop. The Old Trading Post was also known as Wilson's. The store not only carried crafts but, in 1950, was also a headquarters for Eastman and Ansco film. At the time, photography was gaining popularity among tourists who bought and carried small Brownie cameras. This simple point-and-shoot film camera was invented in the early 20th century by Frank Brownell, who gave the camera his name, and was produced for many decades by Eastman Kodak. A close-up of Brownings store appears in the photograph at right. (Above, courtesy of Cherokee Historical Association; right, courtesy of Andy Lett.)

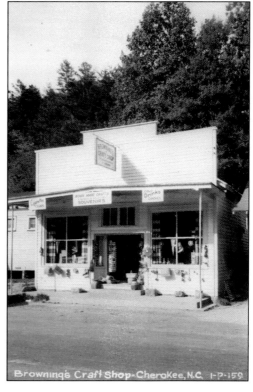

101

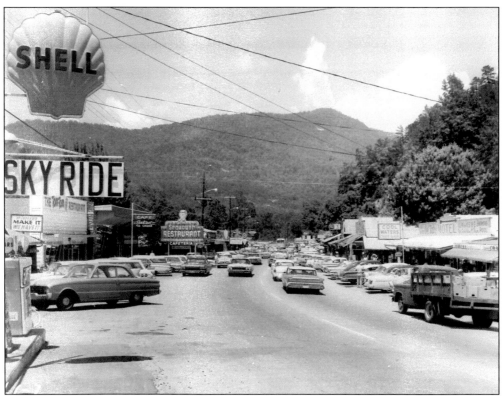

SKY RIDE. The town of Cherokee once had two elevated chairlifts, one right in town and the other at Frontier Land. The Sky Ride in town (above) went over the Oconaluftee River and up over the mountains. This ride had only a chair, while the one at Frontier Land had an enclosed cab. On the left side of the road, just past the Sky Ride, is a sign for the Sequoyah Restaurant. A sign for Cool Waters Café on the right side of the road can be seen in both photographs. (Above, courtesy of the Cherokee Historical Association; below, courtesy of Andy Lett.)

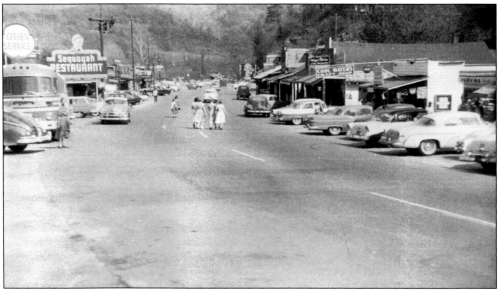

SEQUOYAH RESTAURANT. This restaurant, housed in a small stone building, featured home cooking, including breakfast and sandwiches made on-site. Country cured ham, seafood, steak, and chicken were prepared in the "all electric kitchen." The adjacent motel featured free parking and private baths. With more cars on the road, the business offered free parking in the rear. To the right below, the sign for the Cherokee Chieftain is visible. (Both, courtesy of Andy Lett.)

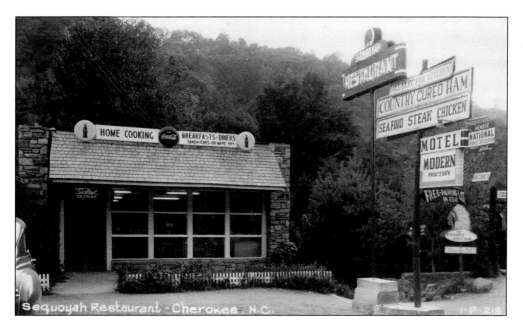

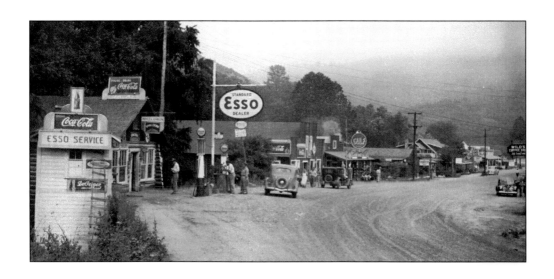

THE CHIEFTAIN. Again, in a view looking toward Mount Noble, the Cherokee Chieftain is barely visible in the center of the photograph above. A sign for Wild's Coffee is at far right. A close-up of the Chieftain can be seen below. In a 1950 ad, the Chieftain, under the direction of Louise and Ross Caldwell, proclaimed 10 years in business carrying the finest "Indian and Mountain crafts." (Above, courtesy of the Museum of the Cherokee Indian; below, courtesy of Hunter Library Special Collections, Western Carolina University.)

THE CHEROKEE CHIEFTAN CRAFT SHOP - CHEROKEE, N.C.

MAIN STREET VIEW. The view of Tsalagi Road above includes the Sequoyah Restaurant and Cherokee Inn on the left, Cayuga farther down the road, and Mount Noble in the far distance. At the far left is a Smoky Mountain Tours bus advertising sightseeing. This was a busy time for Cherokee with a street full of cars and buses. The same stretch of road is pictured from the opposite direction below, with a view looking away from Mount Noble. The distinctive arrowhead-shaped sign of the Cayuga is on the far right. The Cherokee Lodge and Reservation Craft Shop can be seen on the left near a small sign that reads "museum." (Above, courtesy of Andy Lett; below, courtesy of the Museum of the Cherokee Indian.)

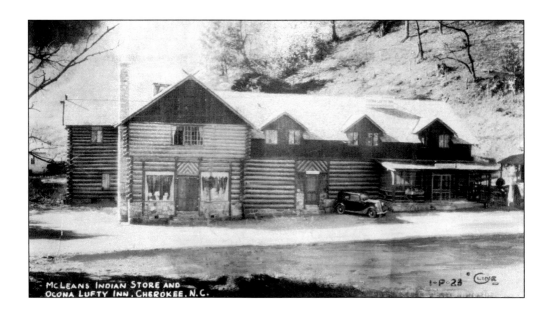

McLeans. This building housed McLeans Indian Store and the Ocona Lufty Inn. In 1948, it became the first building to house the Museum of the Cherokee Indian. In an article from 1934, the year the national park opened, McLeans is listed as one of a handful of commercial shops operating in Cherokee. The museum was founded in 1948. (Both, courtesy of Andy Lett.)

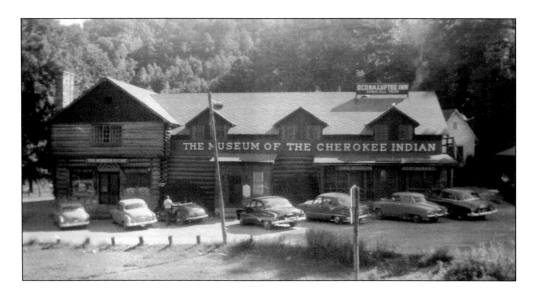

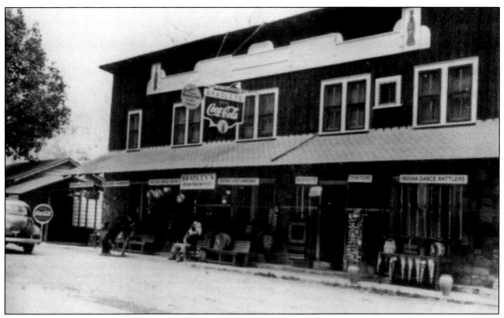

BRADLEY'S. A general store and trading post, Bradley's was located across from the old post office. The store advertised several of the usual items, but it also carried more unique souvenirs like "Indian Dance Rattles," as advertised out front. (Courtesy of Andy Lett.)

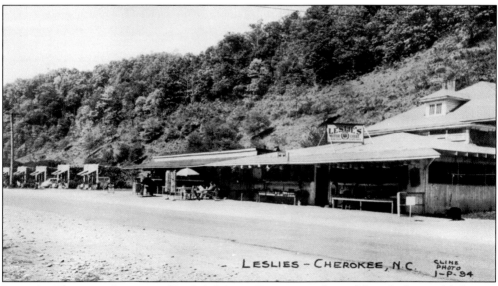

LESLIE'S. The exact location of Leslie's Motor Court is unclear, although the establishment was located in Cherokee, according to this Cline postcard. The site advertised as an American Automobile Association (AAA)-sanctioned motor court with a dining room and craft shop. AAA was founded in 1902 to advocate for better roads to serve the growing number of cars. Throughout the 20th century, the association was known for its maps and for providing a rating system for tourist destinations. (Courtesy of Andy Lett.)

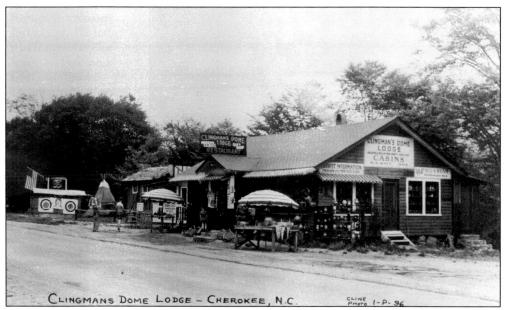

CLINGMANS DOME LODGE. This lodge and craft store is pictured on a postcard by W.M. Cline. The building advertises "Indian and Mountain Crafts" along with "Good Food," including sandwiches, hot dogs, and ice cream made from pasteurized milk. Managed by W.A. Galt, the business was named for nearby Clingmans Dome. Topping out at 6,643 feet, Clingmans Dome is the highest peak in the Great Smoky Mountains National Park and also the highest point on the Appalachian Trail. (Courtesy of Andy Lett.)

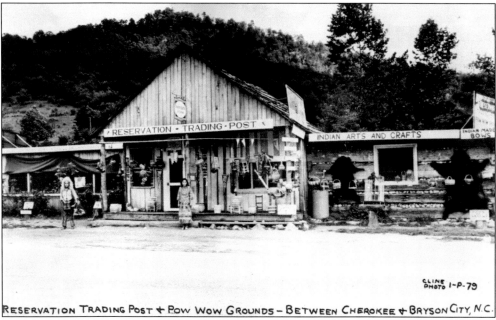

POW WOW GROUNDS. This Reservation Trading Post was located between Cherokee and nearby Bryson City. The Cline postcard also advertises that the site includes "Pow Wow Grounds." Another sign advertises the sale of "Indian Made Bows." (Courtesy of Hunter Library Special Collections, Western Carolina University.)

INDIAN BOUNDARY ENTRANCE. With the building of the Blue Ridge Parkway and the Great Smoky Mountains National Park in the 1930s, the potential for tourism grew. Cherokee is positioned at an advantageous juncture, flanked by adjacent tourist destinations; the town is a gateway to the park and a terminus of the parkway. This photograph shows the entrance into Qualla Boundary from the north. The next few sites pictured follow US Highway 441 south toward town. (Courtesy of the Museum of the Cherokee Indian.)

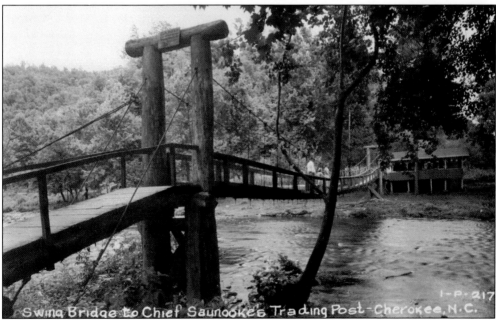

SAUNOOKE'S TRADING POST. This trading post was located on the banks of the Oconaluftee River and included a swinging footbridge that spanned the river. The trading post was located at the north end of town close to the Qualla Boundary entrance, but on the side of the river opposite the park entrance. (Courtesy of Andy Lett.)

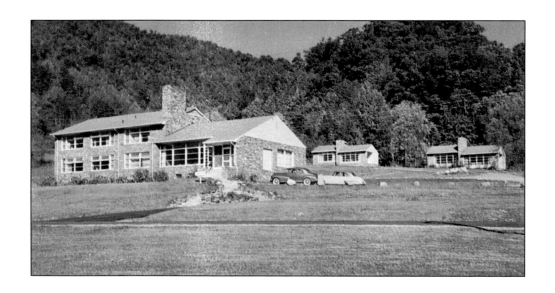

TRIBAL ENTERPRISE. The Boundary Tree Enterprise was built and operated by the Eastern Band of Cherokee Indians as a means of providing revenue to the tribe. It was the first major business encountered on Highway 441 on the way into town from the Great Smoky Mountains National Park. The enterprise included a motor court motel, coffee shop, gas station, and craft shop. A large dining room opened in 1950. Today, the stone building houses the New Kituwah Academy, which teaches in the Cherokee language. The building is located along Highway 441 close to the entrance of the Qualla Boundary. (Above, courtesy of Hunter Library Special Collections, Western Carolina University; below, Museum of the Cherokee Indian.)

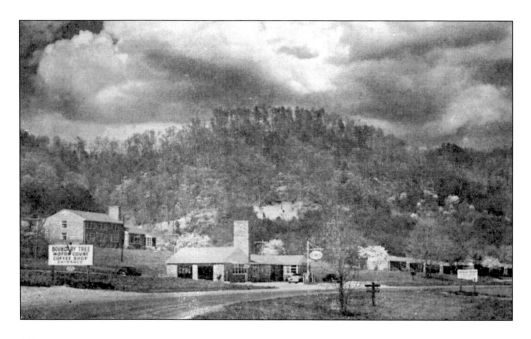

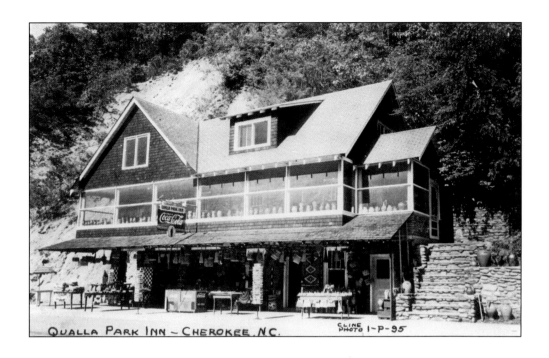

QUALLA PARK INN ~ CHEROKEE, N.C. CLINE PHOTO I~P-95

INN AND TAVERN. Apparently, this business changed hands a number of times. In the postcard above, the building is called Qualla Park Inn, but on several other cards, it is labeled the Cherokee Tavern. In a later postcard, seen below, the same building is labeled the Totem Pole Craft Shop. Today, the building still stands with the same name. Here, the windows along the front are filled with pottery for sale. (Both, courtesy of Andy Lett.)

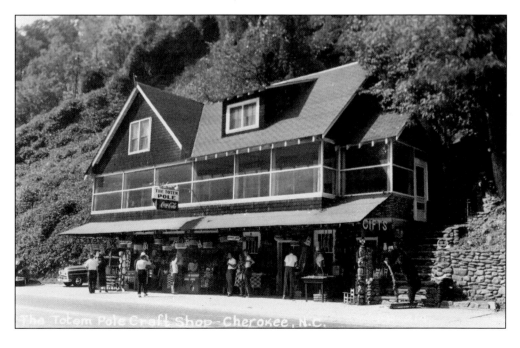

The Totem Pole Craft Shop - Cherokee, N.C.

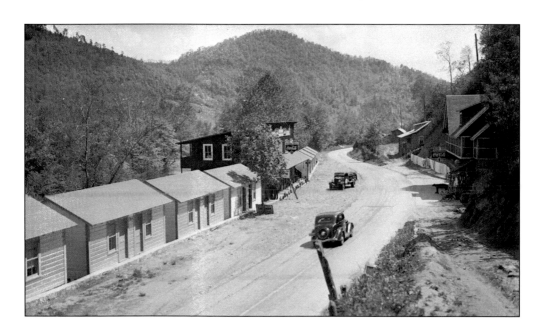

HIGHWAY 441. These are two views of Highway 441 as it enters the Qualla Boundary from the north. In both, a number of roadside cabins sit along the banks of the Oconaluftee River. The Cherokee Tavern is across the road. The photograph above includes a row of cabins that front Route 441. For visitors coming in from the Great Smoky Mountains National Park, these "modern cabins" would have been among the first commercial places outside the park. The larger building, still standing today, was one of many craft shops. At the front of this shop are pottery jars, and hanging from the porch are blowguns. Also a roadside tavern, the establishment served Coca-Cola. A number of textiles hang on a line in front of the tavern. The photograph above is from 1935; the one below is from 1940. Comparing the two views, it is evident that—in just a few years—Cherokee was becoming a major tourist destination. (Both, courtesy of the Great Smoky Mountains National Park Archives.)

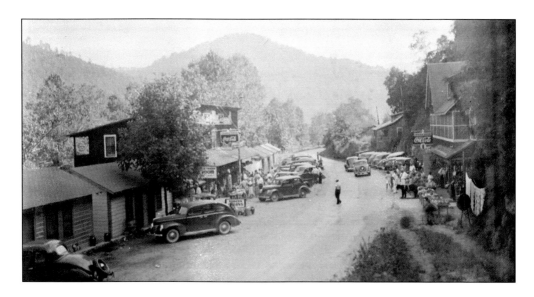

WigWam. The WigWam Motel sits next to the Totem Pole on today's Highway 441. Old neon signs, such as this one, are scattered throughout Cherokee. (Author's collection.)

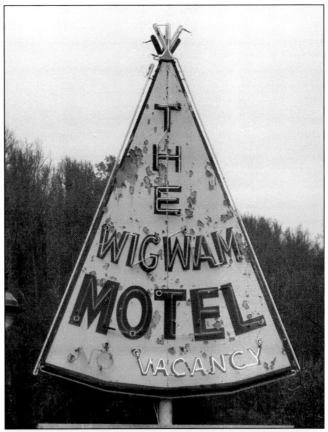

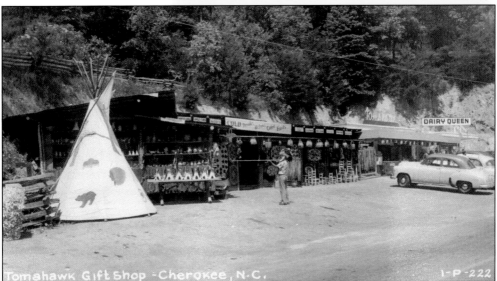

Tomahawk. The location of this gift shop is not known—although according to this postcard, it was located in Cherokee. The shop carried many of the usual items, but it also advertised beadwork and hooked rugs. In front, by the large teepee, is a display of smaller souvenir teepees. The Dairy Queen is at far right. (Courtesy of Andy Lett.)

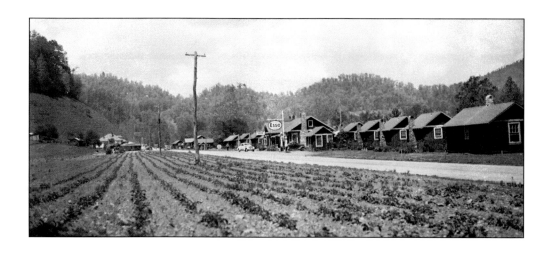

NEWFOUND CABINS. These two photographs show the cabins of Newfound Lodge. Each of the eight small cabins has its own chimney. The dining room and office are centrally located, along with an Esso gas pump that served a growing number of automobiles. (Above, courtesy of the Great Smoky Mountains National Park Archives; below, courtesy of Andy Lett.)

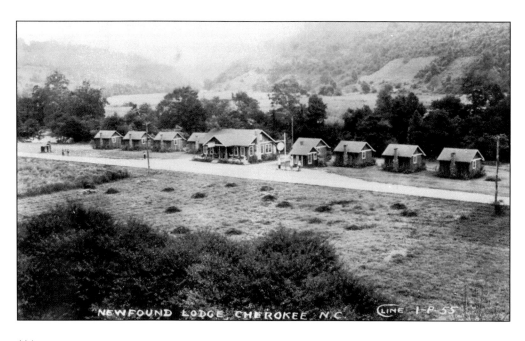

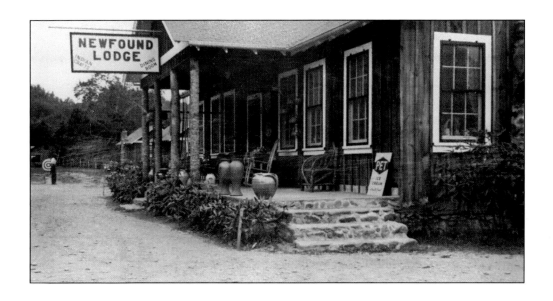

LODGE AND DINING ROOM. Newfound Lodge was opened in 1946 by 23-year-old Lois Queen Farthing. The young businesswoman had gained experience managing a similar business for her parents, Leila Cooper and James Candler Queen, who ran a boardinghouse in Smokemont at the CCC camp in the Great Smoky Mountains National Park. They later built cabins for vacationers. In the photograph below from 1935, the Water Wheel Craft Shop can be seen in the foreground on the left. (Above, courtesy of Andy Lett; below, courtesy of the Great Smoky Mountains National Park Archives.)

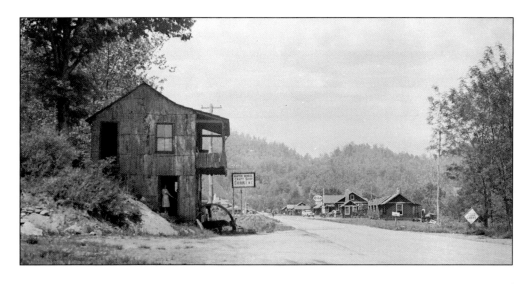

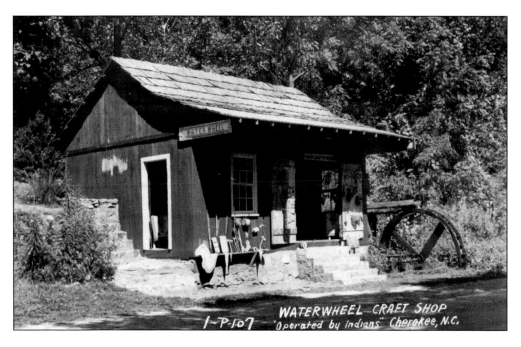

"OPERATED BY INDIANS." The Water Wheel Craft Shop took its name from the metal waterwheel and flume that sat beside the building, at right in both photographs. When in operation, such wheels provided power to the building. The original building (above) has a display of various crafts on the porch and at the front doors. Later, a second building was added alongside. These two photographs are likely from the early to mid-1930s, perhaps just after the opening of the Great Smoky Mountains National Park began to boost tourism in the region. Both were produced and sold as postcards. (Both, courtesy of Andy Lett.)

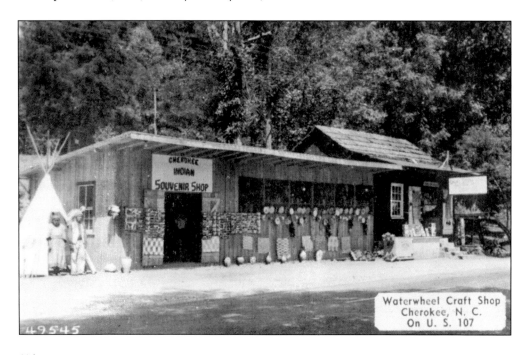

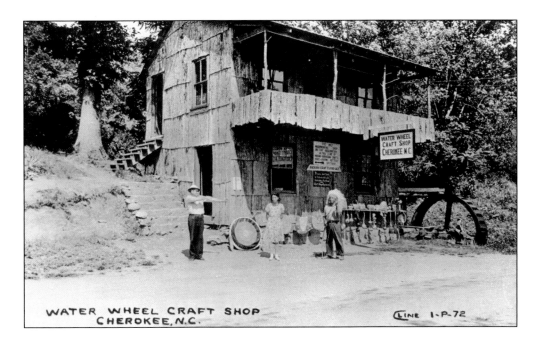

WATER WHEEL CRAFT SHOP
CHEROKEE, N.C.

WATER WHEEL CRAFT SHOP. In the late 1930s or early 1940s, a second-floor gift shop was added and the building was sheathed in bark. A sign on the building explains that the business specializes in woodworking and boasts "a full line of Indian and mountain crafts," including bows, arrows, and pottery. In the photograph above, a tourist tries pulling back on a bow; below, a group of artisans poses in front of the shop. The man at left is carving; the others hold samples of their work. Even at this late date, it looks as if the waterwheel is still functioning, with water spilling out of the flume. (Both, courtesy of Andy Lett.)

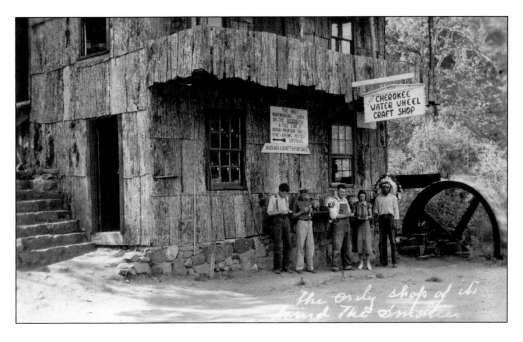

THE CHEROKEES. Downstream on the Oconaluftee River, a field just before town was the location of a business called The Cherokees. Located in a large barn, this enterprise employed local craftsmen who made moccasins and small totem poles carved in wood. While probably an overstatement, the sign boasts, "Largest group of Indian Craftsmen in America!" The silo seen below is still standing today near a roundabout on Acquoni Road. (Both, courtesy of the Cherokee Historical Association.)

Cherokee Tavern, Cherokee, N.C.

Headquarters for Indian Craft and Souvenirs.

SELLING HANDCRAFTS. The postcard above shows a variety of crafts, including a large display of pottery for sale, at the Cherokee Tavern on Highway 441 coming into town from the national park. At the other end of town was the Bigmeet House of Pottery, pictured below. Selling a variety of crafts and specializing in pottery made by the Bigmeat family, the shop was a fixture in town and was located on Paint Town Road across from the casino. The family was tired of explaining their name, so for the shop sign they changed the spelling to "Bigmeet." (Above, courtesy of Andy Lett; below, author's collection.)

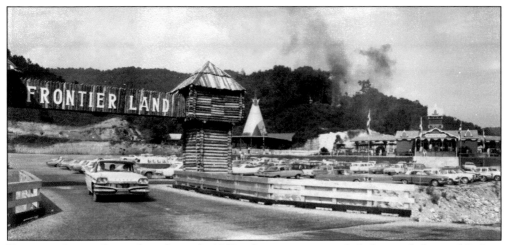

FRONTIER LAND. Opened in the early 1960s, this attraction included a mock fort and Indian village complete with teepees. A settled, farming people, the Cherokee usually lived in log or wood cabins like their Euro-American neighbors, not in teepees that were typical for more nomadic tribes. This amusement park was located on Paint Town Road on what are now the grounds of Harrah's Casino. Frontier Land was a popular tourist site with an admission price of $2.50. The photograph above shows the entrance to the park via a bridge over Soco Creek. The park also had its own narrow-gauge railroad that was advertised as an "authentic wood-burning 1860 train." The smoke visible in the center of the photograph is from that excursion train. The picture below shows the Gondola Sky Ride with two cable cars passing overhead. (Both photographs by Jim R. Jernigan, courtesy of Andy Lett.)

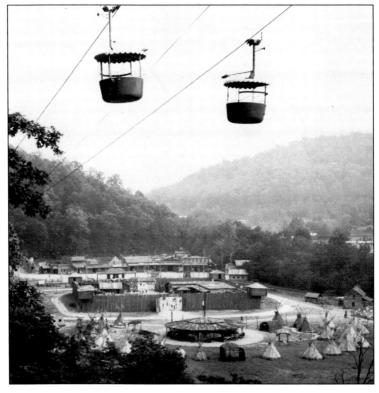

FORT AND INDIAN VILLAGE. This depiction of Cherokee was a Hollywood version of a "Cowboys and Indians" set. The photograph above shows a fort surrounded by a stockade fence where Indians "attacked" every hour on the hour. In the background are the Last Chance Saloon and Pioneer Junction, a cafeteria that served refreshments and full-course meals to visitors. A flyer advertising the destination outrageously proclaimed that the fort was "built to protect the little town of Pioneer Junction from the hostile redmen in Indian Territory." The amusement park was operated from sometime around 1962 until 1983, when it became the Magic Waters Fun Park. In 1997, the location became the site of Harrah's Cherokee Casino Resort. (Both photographs by Jim R. Jernigan, courtesy of Andy Lett.)

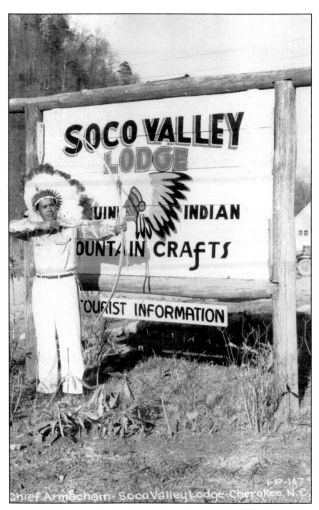

Chief Armachain- Soco Valley Lodge-Cherokee, N.C.

SOCO VALLEY LODGE. Soco is a community located along Highway 19 at the eastern edge of the Qualla Boundary. The community runs along Soco Creek. At left, Chief Armachain poses in front of a sign for the Soco Valley Lodge, pictured below. (Both, courtesy of Andy Lett.)

Soco Valley Motor Court - Cherokee, N.C.

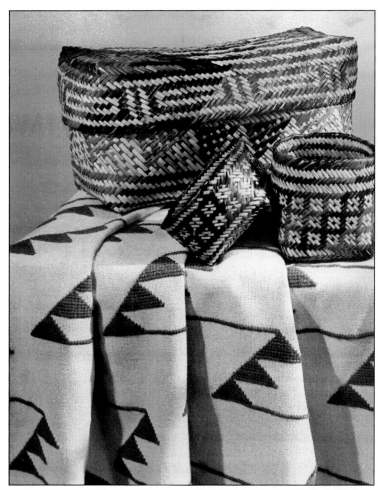

ROAD TO SOCO. The Soco Valley Lodge and the Soco Valley Motor Court (below) are two of the few businesses that are strung along Highway 19 on the way to Maggie Valley. The winding highway was the inspiration for a weaving pattern (right) made in the 1930s by Roxanne Stamper. This weaving—titled *Road to Soco*—was shown at the 1939 World's Fair in San Francisco. (Right, courtesy of the Southern Highland Craft Guild Archives; below, courtesy of Andy Lett.)

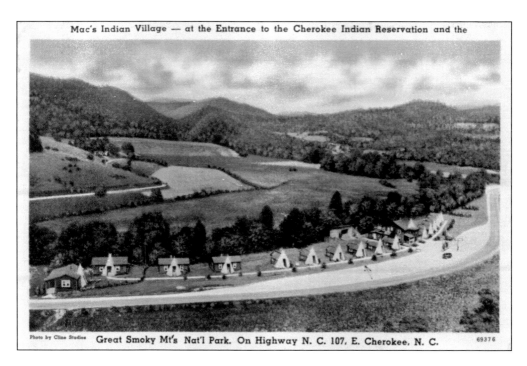

Mac's Indian Village — at the Entrance to the Cherokee Indian Reservation and the

Photo by Cline Studios Great Smoky Mt's Nat'l Park. On Highway N. C. 107, E. Cherokee, N. C. 69376

CLINE POSTCARDS. These two postcards feature Mac's Indian Village, located on old Highway 107 as it leaves Cherokee. Both were produced by W.M. Cline of Chattanooga, Tennessee. After running a black-and-white operation for several decades, in 1958, W.M. Cline Jr. opened a color plant that could print 6,000 postcards per hour from more than 30,000 stock negatives. The photograph above is an example of one of its hand-colored postcards. (Above, courtesy of Hunter Library Special Collections, Western Carolina University; below, courtesy of Andy Lett.)

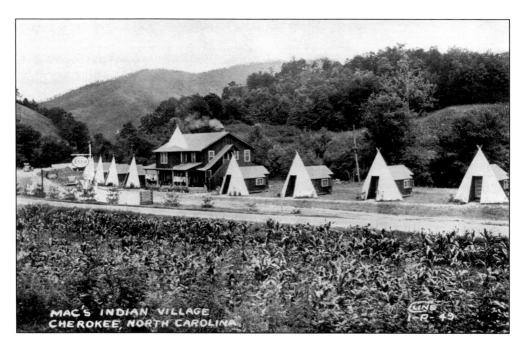

MAC'S INDIAN VILLAGE
CHEROKEE, NORTH CAROLINA

MAC'S INDIAN VILLAGE.
The remains of this unique roadside resort are located along Soco Creek between Tee Pee Drive and today's Highway 441. The building with its teepee entrance is original and can be seen at far left in the Cline postcard on the opposite page. The village was built in 1934, the same year that the Great Smoky Mountains National Park opened. Originally, there were 16 cabins, each with a 12-foot-tall teepee at the entrance. A few teepees and cabins are still in use, and the single teepee pictured at right remains. (Both, author's collection.)

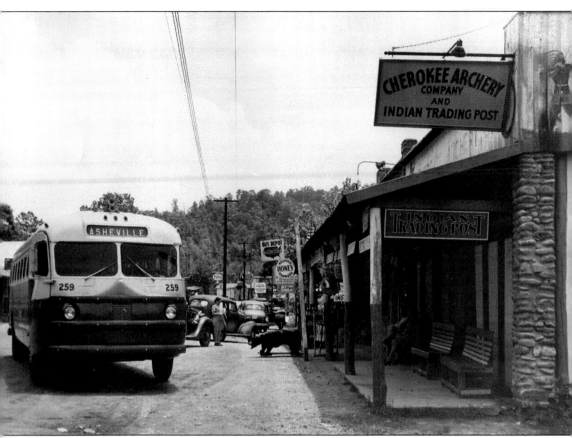

BUS FROM ASHEVILLE. The town of Asheville is located about 50 miles east of Cherokee. Tour buses such as this one brought visitors from Asheville and other parts of North Carolina into Cherokee. This bus is parked in front of the Cherokee Archery Company. A bit farther down the block is a sign indicating the bus depot. The photograph dates to 1945. (Photograph by John H. Hemmer, courtesy of the State Archives of North Carolina.)

OLD MILL. This old mill with its prominent waterwheel sat along old Highway 107 for many years until it tragically burned in 2017. The gristmill dated to 1886. Old photographs like this one are important, as they capture the fading presence of old buildings and the changing personality of a community's cultural landscape. (Courtesy of Andy Lett.)

DISCOVER THOUSANDS OF LOCAL HISTORY BOOKS
FEATURING MILLIONS OF VINTAGE IMAGES

Arcadia Publishing, the leading local history publisher in the United States, is committed to making history accessible and meaningful through publishing books that celebrate and preserve the heritage of America's people and places.

Find more books like this at
www.arcadiapublishing.com

Search for your hometown history, your old stomping grounds, and even your favorite sports team.

Consistent with our mission to preserve history on a local level, this book was printed in South Carolina on American-made paper and manufactured entirely in the United States. Products carrying the accredited Forest Stewardship Council (FSC) label are printed on 100 percent FSC-certified paper.

MADE IN THE USA

MAR - - 2022